MEXICAN AMERICAN
BASEBALL IN
LOS ANGELES

To Ronnie and Pauline,

This book is dedicated to

All the great Mexican American

Teams, players, coaches, umpires,

And sponsors who brought so much

Joy and honor to their community fans.

Best wishes always,

Richard Santillan
May 27, 2012

ON THE FRONT COVER: "The Spanish Tornado," Elías Baca, played for UCLA during the Great Depression and upon graduation became the first Mexican American teacher in his hometown of Casa Blanca, California.

COVER BACKGROUND: The Carmelita Provision Company, CPC or Chorizeros (the sausage makers), wear the 1953 Los Angeles City Championship badges—one of many city championships. (Courtesy of the Latino Baseball History Project.)

ON THE BACK COVER: The nine Peña brothers pose along with their father, William Peña, in the Orioles uniform. Their story was submitted to *Ripley's Believe It or Not*. (Courtesy of the Latino Baseball History Project.)

MEXICAN AMERICAN
BASEBALL IN
LOS ANGELES

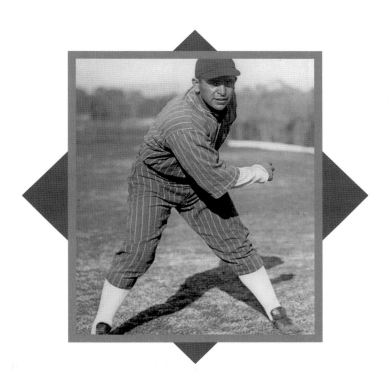

Francisco E. Balderrama and Richard A. Santillan
Foreword by Samuel O. Regalado

ARCADIA
PUBLISHING

A Cristina, querida compañera de mi vida.

—*Francisco*

For Teresa, my wife and inspiration.

—*Richard*

Copyright © 2011 by Francisco E. Balderrama and Richard A. Santillan
ISBN 978-0-7385-8180-4

Published by Arcadia Publishing
Charleston, South Carolina

Printed in the United States of America

Library of Congress Control Number: 2010932243

For all general information, please contact Arcadia Publishing:
Telephone 843-853-2070
Fax 843-853-0044
E-mail sales@arcadiapublishing.com
For customer service and orders:
Toll-Free 1-888-313-2665

Visit us on the Internet at www.arcadiapublishing.com

CONTENTS

ACKNOWLEDGMENTS

The publication of *Mexican American Baseball in Los Angeles* is largely due to the dedication and hard work of the men and women associated with the Latino Baseball History Project. Further information about this organization is presented on page 127. Individuals involved with the project who have supported the writing of this book include California State University, San Bernardino library dean César Caballero; CSUSB Special Collections curator Jill Vassilakos-Long; CSUSB administrative analyst Iwona Contreras; Baseball Reliquary executive director Terry Cannon and artist and art consultant Tomás Benitez.

Since the inauguration of the project at California State University, Los Angeles, the Los Angeles Dodgers have also lent their assistance. Furthermore, Cal State L.A. students in the class Chicano Studies 490/History 450: Mexican American Baseball and Oral History played essential roles. The students conducted oral histories and collected photographs for the highly successful exhibitions designed and assembled by Terry Cannon, first at Cal State L.A. and then elsewhere. Many of the photographs and other artifacts, as well as recollections and testimonies appearing here, were drawn from those exhibitions. Unless otherwise noted, all the images appear courtesy of the Latino Baseball History Project. Other local historical organizations and libraries also uncovered materials. Among them were the La Historia Society of El Monte and the Los Angeles Public Library. An especially important contribution to the book has been the impressive artwork of Ben Sakoguchi, which presents an unauthorized history of Mexican American baseball.

The donors of photographs are too numerous to mention individually. However, former players Al Padilla, Art Velarde, and Richard Peña (in addition to other members of the Peña family) spent considerable time encouraging others to contribute photographs. Professional photographer Ron Regalado also made available the invaluable Manuel Regalado baseball collection of photographs and documents. Furthermore, the scholarship of historian Samuel O. Regalado was a critical resource for this pictorial history. The authors were delighted when he graciously agreed to write the foreword. Terry Cannon's encyclopedic knowledge of baseball was called upon at a number of critical moments during the writing of this book. In addition, research assistant Mark Ocegueda's commitment to the project and book was inspirational.

The authors are most grateful to the players, as well as their families and fans, who have contributed their photographs; by doing so, they have told us the story of American baseball in Mexican Los Angeles. We also thank Arcadia Publishing and editor Jerry Roberts.

FOREWORD

It seemed like only yesterday that I was spending my summer Sundays in the company of my uncle Greg and cousin Ron at the Belvedere Park baseball diamond in East Los Angeles. My grandfather Manuel, happily attired in his beloved 1930s flat cap and looking very important, was there as well, munching on a cigar stub and holding onto a well-worn score book. Within minutes, my uncle, a standout player in his day, was warming up with his teammates on the field, all of them in dashing white uniforms that bore the name "Forty-Sixty" on their jerseys, topped off with blue baseball caps that displayed white "LA" lettering stitched onto a sea of blue.

The staging in the park was also memorable. It included the aroma of fresh tamales, beans, and tortillas. And as game time neared, families crept onto the grounds and planted themselves underneath the shade of large trees, while little kids mimicked the players and tossed about baseballs. Mariachis, in their *charro* outfits, were not far behind as they scattered among the growing crowd. On the field itself, players exchanged pleasantries in Spanglish, while others taped up their well-worn equipment that had seen better days. This was the world of baseball in the barrios, where, on Sundays, the diamonds of East Los Angeles were the center of community attention; a place to play, gather, network, and, of course, be seen. It was a forum that fed into their Mexican identity.

In *Mexican American Baseball in Los Angeles*, a book that displays an impressive collection of photographs, historians Francisco E. Balderrama and Richard A. Santillan capture the spirit of the game in the Mexican American enclave. From 1900 to the "Fernandomania" era of the 1980s, the authors present glimpses of Mexican American baseball at several different levels in several eras: youth, semiprofessional, and adult amateur. Played with vigor, the game spoke to the players' competitiveness as it did to their culture. Anchored in a history that was both regional and transnational, this photo-documentary confirms that such teams as the talented Chorizeros, the Los Angeles Forty-Sixty Club, and others were, in their time, the face of Mexican Los Angeles. And, for those of us who were lucky enough to be part of this environment, the authors remind us that baseball was more than just a game—it was a component of our culture.

—Samuel O. Regalado

INTRODUCTION

This photo-documentary chronicles baseball and its social and cultural impact on Mexican Los Angeles, primarily from 1900, with the establishment of the Mexican immigrant community, to the rise of "Fernandomania" in the 1980s. Particular emphasis is given to the era of segregation. Even though some attention is given to the rise of individual major-league players, the emphasis is on the celebration of ethnic identity and community pride, especially in East Los Angeles.

Many Mexican and Mexican American youths played baseball in high schools and colleges as an entry path to an education and a career. The "Spanish Tornado," pitcher Elías Baca, for example, after playing on the UCLA team during the Great Depression, devoted his life to being an educator. Baseball was not only for youth, as there also was the famous Forty-Sixty Club comprised of players at least 40 years of age and often older than 60. Regardless of their age, players and the Los Angeles community prized baseball as a venue where Mexican athletic talent and skill were tested against African Americans, Japanese Americans, and Anglo Americans, especially for the amateur and semiprofessional teams.

There also was the opportunity to compete against teams from the Mexican nation, which often traveled to the southland. The Mexican clubs would often reciprocate the hospitality with invitations to the leading clubs of the east side to travel to Mexico to play. This flourishing culture of American baseball in Mexican Los Angeles brought about the famous Chorizeros, frequently referred to by contemporary historians as the "Yankees of East L.A." because of their many city championships and packed Sunday games.

The coming of major-league baseball with the arrival of the former Brooklyn Dodgers in Los Angeles for the 1958 season marked the beginning of an important new baseball era. The controversial displacement of the largely Mexican community of Chávez Ravine and the use of this land for the construction of Dodger Stadium were viewed as terrible wrongs against the Mexican community. On the other hand, the Dodgers, upon their arrival in Los Angeles, campaigned for Mexican American baseball fans.

The Dodgers were the first major-league club to develop Spanish-language broadcasting of their games on radio and to distribute game programs in Spanish. The rookie season of Fernando Valenzuela in 1981 would bring about "Fernandomania" and secure a solid fan base among Mexicans in Southern California.

MEXICAN AMERICAN BASEBALL
A GENUINE NATIONAL PASTIME

A Poetic Tribute to Baseball's Hispanic Names

There are certain names that go over well
Like Pena, Ramos and Carrasquel
With liquid sounds so panoramic
And strangely they are all Hispanic
Aurelio, Hipolito, Cecilio, Domingo
Have a lovelier sound than American lingo
What other name could I tell so musically as Valdivielso?
And no other native name could ever show us the splendor
Of Salome Barojas!

—Bob Sheppard, *New York Daily News*, July 11, 2010

Baseball has been a foremost presence in the lives of Mexican Americans since the early 20th century. Throughout the United States, baseball took on a special significance, especially during the period from the 1920s to the 1960s, which was considered the Golden Age of Mexican American baseball. More than merely games for boys and girls, baseball contests and teams involved nearly the entire community and often had important social, political, and cultural dimensions. Along with family and religion, baseball was an institutional thread uniting the community.

Many ballplayers starring outside of California eventually migrated to the greater Los Angeles area, adding to an already vibrant Mexican baseball community. Moreover, several sons of out-of-state former ballplayers grew up playing and coaching baseball in Los Angeles, which assisted in promoting Los Angeles as a hotbed of baseball. In order to truly appreciate the development of baseball in Los Angeles, a national perspective is required to understand the critical link of out-of-state players to the development of baseball in greater Los Angeles.

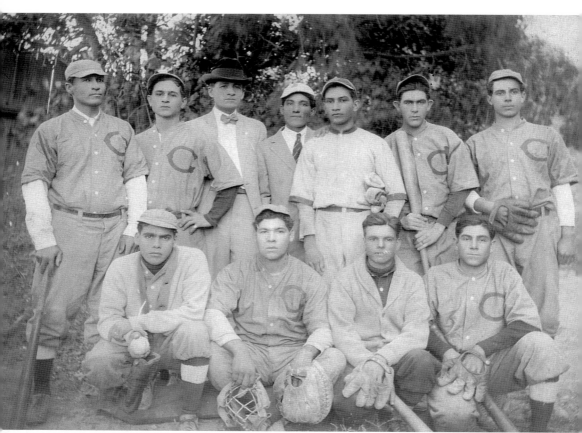

In 1914, the Groves baseball team of Tucson, Arizona, was named after the field they played on, which was literally in the groves. Manuel Padilla (first row, second from left) worked for the Southern Pacific Railroad Company as a boilermaker. He was an outstanding high school and semiprofessional player. His son Al would eventually become a legendary baseball player, as well as a highly regarded high school and college coach in Los Angeles.

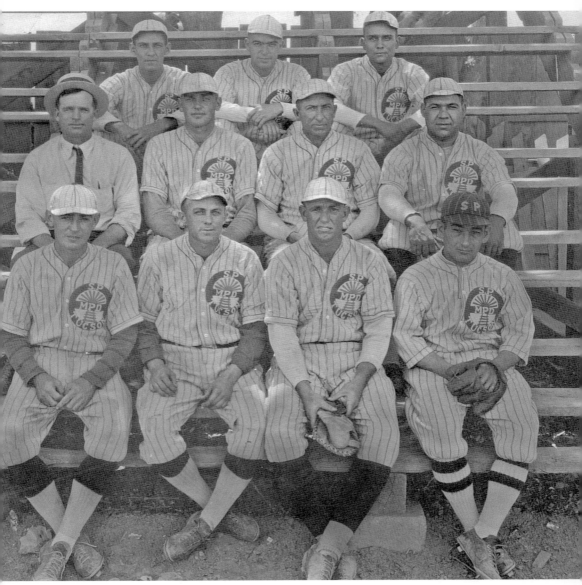

In Tucson, Arizona, the Southern Pacific Motive Power of 1923 was a semiprofessional team sponsored by Southern Pacific Railroad. Al Padilla remembered that his father, Manuel (second row, far right), passed away at the young age of 44 due to the physical demands of work and playing baseball almost full-time. Many players' lives were cut short due to the horrific working conditions and the endless practices and games.

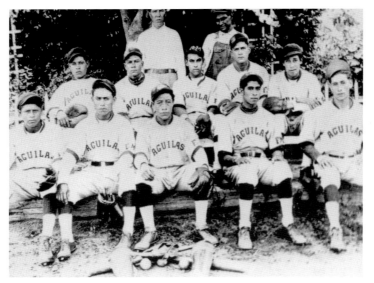

The Fort Madison, Iowa, Mexican baseball team, seen here around 1935, had a highly patriotic name—Las Aguilas (the Eagles). The eagle is a symbol of Mexico and is depicted on its national flag. Sabastián Alvarez (second row, second from left) was scouted by the Chicago Cubs and offered a tryout, but he refused because he had to support his family during the Great Depression.

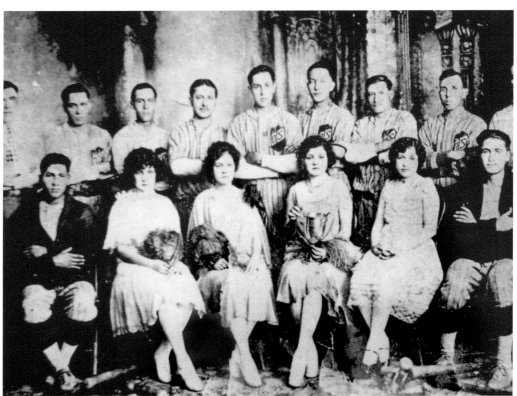

The East Chicago, Indiana, baseball team of 1917 worked at the Inland Steel Company, the largest employer of Mexican labor in the entire United States. The steel companies sponsored baseball teams, often dominated by Mexican players. Being an excellent ballplayer was a sure way to be hired.

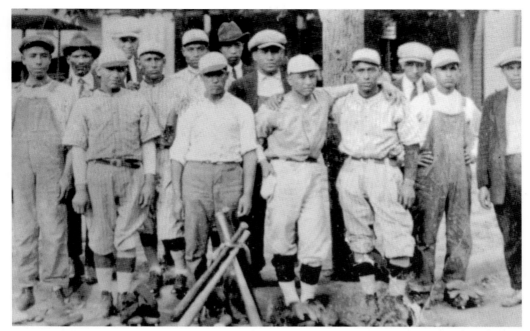

The Horton, Kansas, baseball team, seen here around 1924, worked for the Rock Island Railroad Company in the repair shops or the roundhouse. Railroad companies sponsored teams throughout the United States. As with the steel mills, being an outstanding player was a ticket to employment because businesses wanted to have winning teams. Companies went out of their way to seek out outstanding Mexican players.

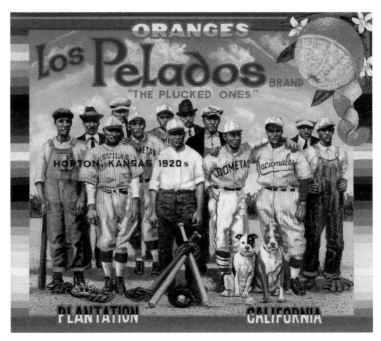

Los Pelados Brand (the Plucked Ones), by artist Ben Sakoguchi, underscores the working-class origins of the Mexican community throughout the United States during the early 20th century. He has inscribed the popular names given to Mexican baseball teams on the uniforms of the c. 1924 Horton, Kansas, team photograph. (Courtesy of Ben Sakoguchi.)

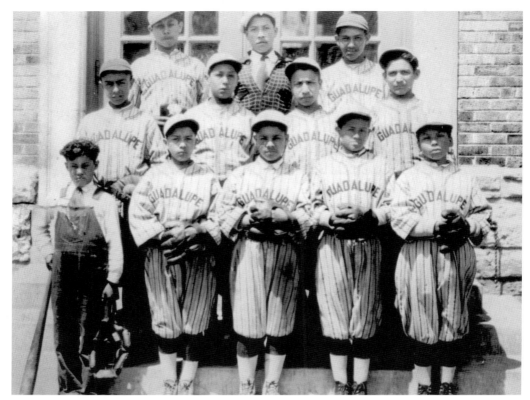

The Guadalupe baseball team in Kansas City, Missouri, seen here around 1935, was one of many sponsoring efforts by the Catholic Church involving the introduction of baseball to Mexican youth. Catholics sponsored several baseball leagues: the Catholic Youth Organization (CYO), Catholic Baseball League, and the Mission League. Mexican teams played other ethnic Catholic parishes and often won their games and tournaments.

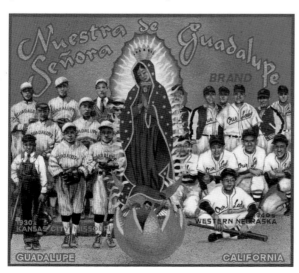

Nuestra Señora de Guadalupe Brand (Our Lady of Guadalupe) by artist Ben Sakoguchi honors the Mexican American baseball teams that played under the name of Mexico's patron saint. She is one of Mexico's most popular religious and cultural images. (Courtesy of Ben Sakoguchi.)

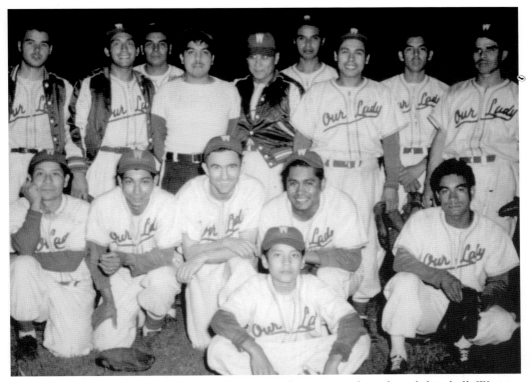

After World War II, the Catholic Church continued its sponsorship of youth baseball. Western Nebraska Our Lady of Guadalupe baseball team, pictured around 1948, is an example. Baseball had an amazing revitalization after the war, and its popularity was directly linked to the political and civil rights activities of the Mexican American community as it demanded equal sports participation in both educational and public facilities.

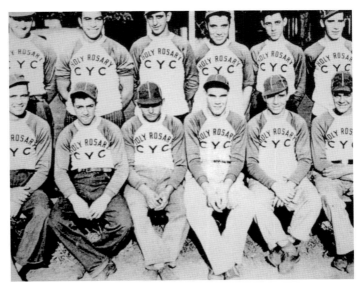

Seen here around 1946 in Bethlehem, Pennsylvania, the Holy Rosary baseball team was a popular club during the World War II era when many Mexicans in the Midwest sought work in Ohio, Pennsylvania, and New York at the steel mills and railroads. After World War II, the Catholic Church also regarded its practice of offering baseball to Mexican youth as a form of recreation and keeping them out of trouble.

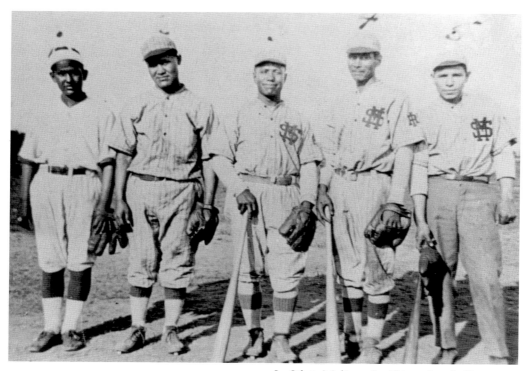

In Silvis-Moline, the Illinois baseball team of 1926 was a highly competitive club in the Quad Cities area of Iowa and Illinois. The four Mexican communities of Davenport and Bettendorf, Iowa, and Silvis and Moline, Illinois, played hard-fought games for championships and community pride. Mexicans residing in the Quad Cities had come to work in the railroads, on farms, and in construction equipment plants, icehouses, and textile mills.

Traveling for baseball games also provided opportunities for many Mexican American players to date and sometimes marry girls from neighboring communities. An important outcome of these marriages was the emergence of a family network across the region. This matrix of families contributed significantly to the emergence of the post–World War II civil rights movement.

The *Aztecas del Norte Brand* (Aztecs of the North) by artist Ben Sakoguchi depicts two of the Azteca teams from Kansas. The Aztec figure in the center is holding a baseball bat, and his head piece consists of the national colors of Mexico and the United States, a reference to the Mexican American backgrounds of the teams. (Courtesy of Ben Sakoguchi.)

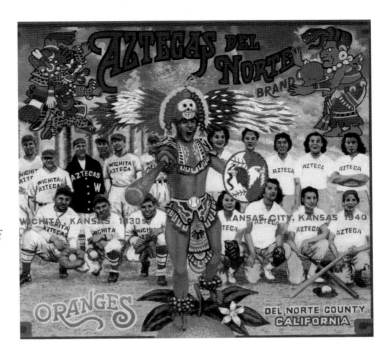

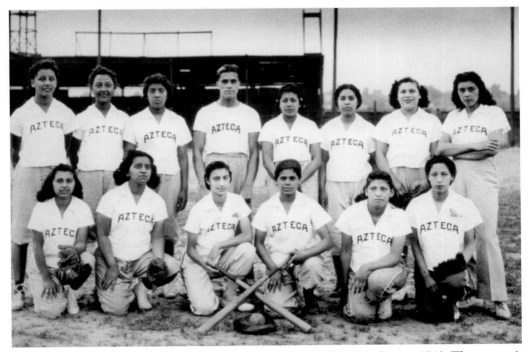

Another leading women's baseball team was Las Aztecas of Kansas City in 1940. The women's teams often traveled with the men's teams. In addition to concurrent games, there were sometimes doubleheaders, with the women playing in the morning and the men playing afterwards.

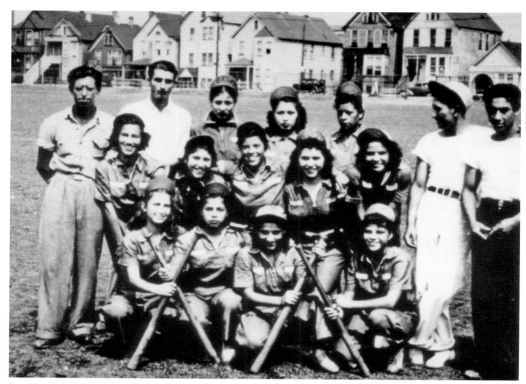

In this *c.* 1939 team picture is Las Gallinas (the Hens) from East Chicago, Indiana. The Hens were one of several prominent Mexican women's teams. All-male staffs managed and coached these teams, and games were often played in small, nearby fields while the men's team, Los Gallos (the roosters), played on the major diamonds.

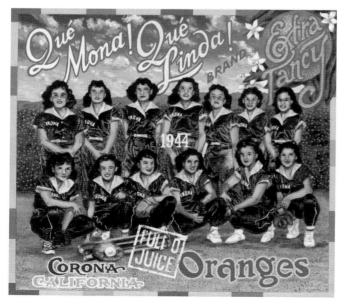

Qué Mona! Qué Linda! Brand (How Cute, How Pretty) by artist Ben Sakoguchi celebrates the fact that women, not only men, played baseball through this portrait of a 1944 team. (Courtesy of Ben Sakoguchi.)

Women were very active in both baseball and softball as fans as well as players.

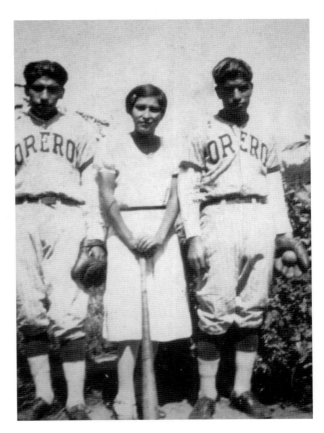

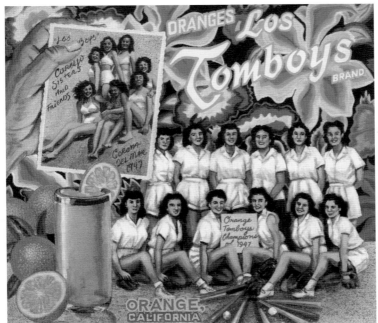

Los Tomboys Brand by artist Ben Sakoguchi commemorates the Tomboys, champions of Orange, California, in 1947. (Courtesy of Ben Sakoguchi.)

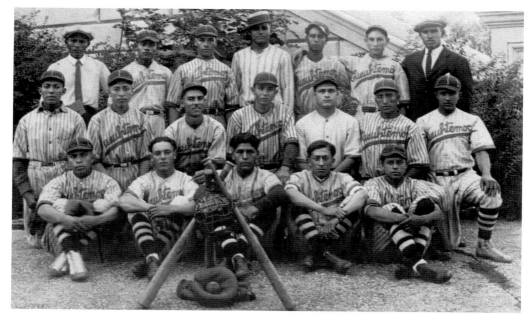

The Topeka, Kansas, Cuauhtemocs baseball team of 1929 was one of several Mexican American teams across the United States that adopted the name of Los Cuauhtemocs; it was a tribute to the last Aztec King Cuauhtemoc, who only ruled from 1519 to 1521, until the Spanish conquest of Mexico.

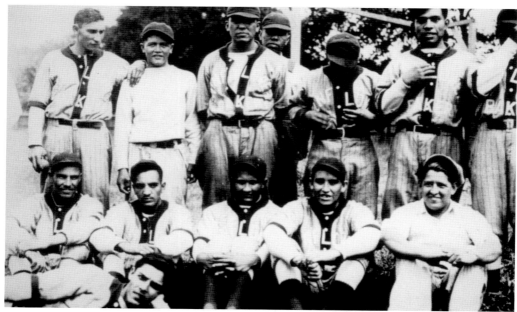

The Kansas Los Bakers of 1932 played by making their own fields, frequently in vacant lots or in pastures near the railroad tracks, roundhouses, or steel mills. Women made the bases by sewing anew worn-out pillows; sometimes dried-out cow chips were used as bases.

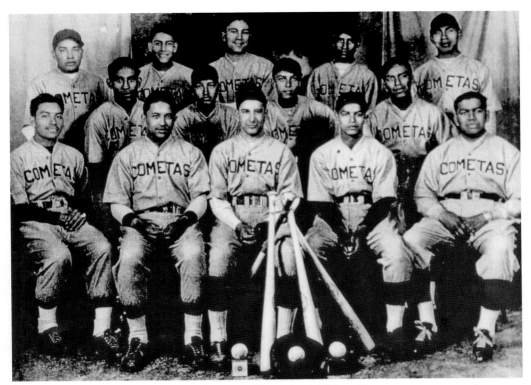

The Cometas (Comets) of 1933 and Piratas (Pirates) of 1930 in Kansas were among the teams that followed the tradition of adopting names in Spanish, probably because of the racist exclusion of Mexicans from playing in public leagues and parks. As a consequence, Mexicans established an elaborate network of community teams, leagues, and fields in the Jayhawk state. Adopting Spanish names reaffirmed their language and identity as Mexicans.

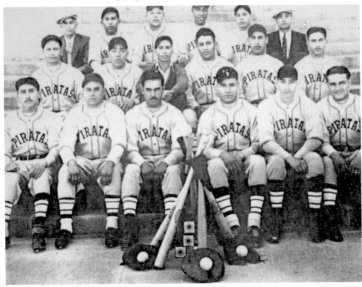

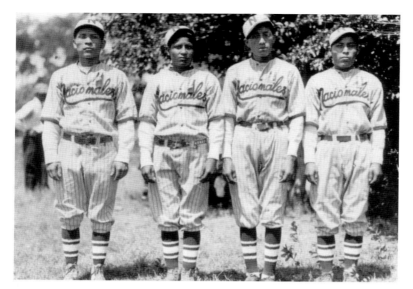

The Nacionales of Wichita, Kansas, are seen here around 1926. Many Midwestern teams played on fields with colorful names such as La Yardita (Little Yard), Devil's Field, and El Parque Anahuac (the Park of the Ancient Valley of Mexico).

The Kansas McGee team of 1948 played in the Newtown softball tournament. The tournament continues today in promoting longtime cultural and social roles in the Mexican American community. Along with games, there are picnics, dances, and activities for the children. Many tournaments also sponsor senior games for the new generation to see the outstanding players of the past. These activities, among others, center on family, friendship, and community unity.

Pictured around 1939, the Scottsbluff, Nebraska, baseball team was composed of players engaged in agriculture. Scottsbluff is located in the western region of Nebraska. Most of the Mexicans worked in the large sugar beet factories and fields located throughout the Midwest from Nebraska to Minnesota.

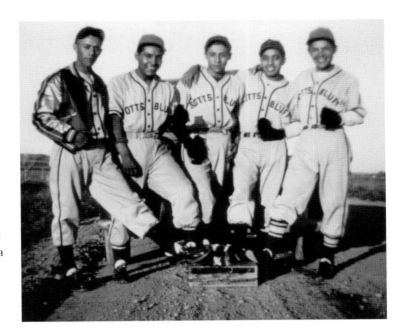

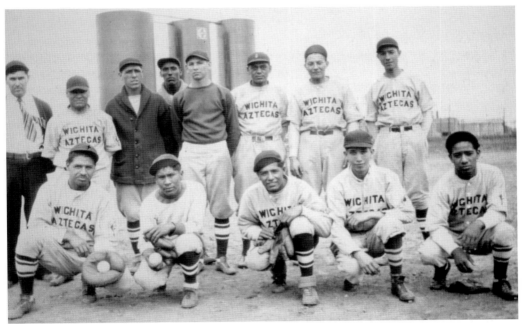

The Wichita Aztecas of the 1930s was one of many Aztec teams whose players and their families loaded up in cars or chartered buses at the end of the workweeks and headed off to their destinations, arriving late on Friday nights or early Saturday mornings. They visited family and friends on Saturday evenings at giant receptions featuring food, music, and dancing. Sometimes hundreds, perhaps thousands, of Mexican American fans watched games and cheered for their homegrown heroes and teams in hundreds of Mexican American communities.

Phillip Gutiérrez was considered one of the great Mexican ballplayers to come out of Kansas. He played for the Kansas Chanute Aguilas in the 1930s. Like so many of his generation, Phillip enlisted during World War II. Mexican American ballplayers throughout the United States put away their gloves and bats and enlisted in the military to defend their country despite the discrimination directed against them. Many men were decorated for their bravery. Sadly, Gutiérrez was killed in action.

Art Velarde (first row, third from right) is seen here before becoming an East Los Angeles player who would end up playing on various clubs from the playgrounds to Roosevelt High School, UCLA, and Sunday teams. His playing of baseball began in Gallup, New Mexico, for the Santa Fe Yankees in 1947.

MEXICAN AMERICAN BASEBALL

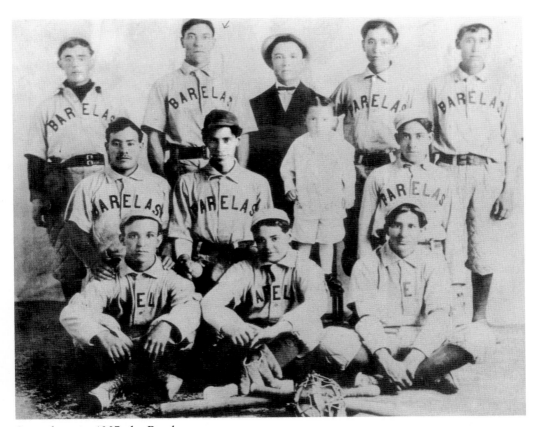

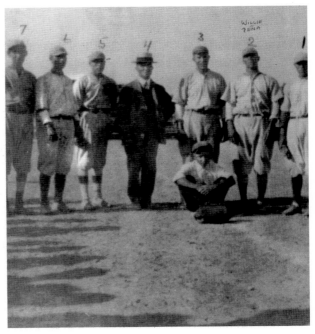

Seen above in 1907, the Barelas team of Albuquerque, New Mexico, highlights the impact baseball had on father–son relationships for Mexican Americans. The manager, Dan Padilla (third row center in civilian clothes), poses with his team and his young son Placido Padilla. At right, father and son appear again eight years later as manager and batboy in 1915. Future Los Angeles player William Peña also appears in the images above (third row, second from left) and at right and would teach all nine of his sons to play baseball. All the sons played semiprofessional baseball in Los Angeles and some would seek professional careers.

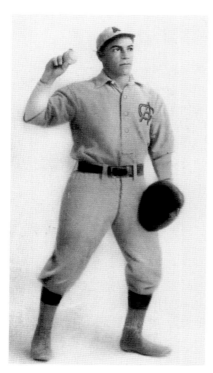

In 1910, at 19 years of age, William Peña was a catcher for the Grays, a minor-league team in Albuquerque, New Mexico. He played for almost seven years at Tingley Field, the former home of the minor-league Albuquerque Dukes. Peña had a long career as a ballplayer, even volunteering in an East Los Angeles game at the age of 64 to go behind the plate when a team ran short of catchers.

By the 1940s, if not sooner, women and men were interested in baseball and softball, as indicated by this photograph of Mexican American women in Newton, Kansas.

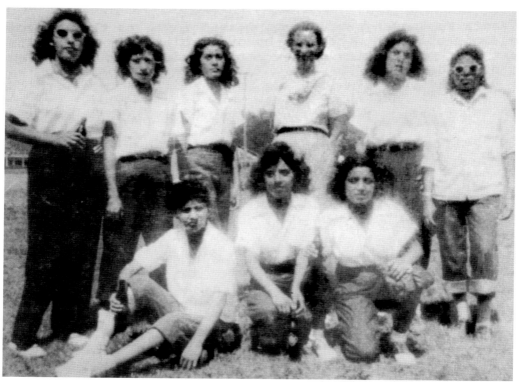

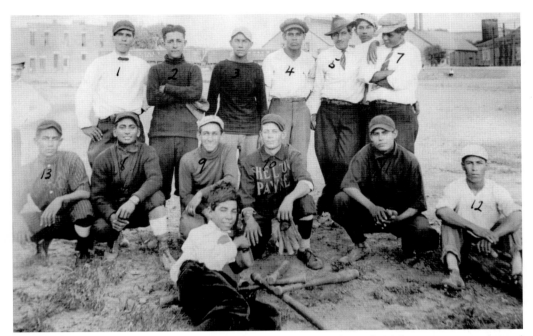

Baseball was popular on the United States–Mexico border in the early 20th century, as evidenced by this pickup team from East El Paso, Texas, in 1913.

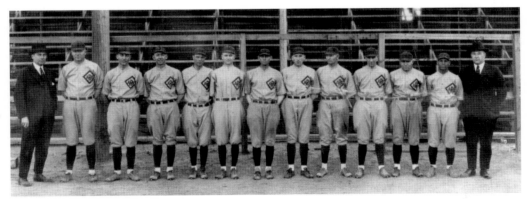

An early significant professional ballplayer during the 1920s was Robert Lagunas, who appears in this team photograph (second from right). "Lakes," the English translation of his last name, became his nickname. Before moving to Southern California during the 1930s, he played for the El Paso, Texas, team of the Texas–New Mexico League, where he endured significant prejudice as quite often the only Mexican on the team. After playing a game with the St. Louis Cardinals, Baseball Hall of Famer Rogers Hornsby refused to shake Lagunas's hand when it was offered because of Lagunas's Mexican background.

ST. LOUIS—	AB	H	PO	A	E	
Blades, lf	5	0	2	1	0	0
Douthit, cf	5	1	1	2	0	0
Hornsby, 2b	4	2	3	1	3	0
Bottomley, 1b	5	0	0	5	2	0
Hafey, rf	5	1	3	1	0	0
Bell, 3b	4	2	0	1	2	0
Warwick, c	4	1	1	11	1	0
Thevenow, ss	4	1	3	5	4	1
Myers, p	1	0	0	0	0	0
Keen, p	2	0	0	0	1	0
Huntzinger, p	1	0	0	0	0	0
Totals	40	8	13	27	13	1

WACO—	AB	R	H	PO	A	E
Lagunas, ss	4	1	1	3	3	1
Wilson, lf	4	1	1	1	0	0
Davis, cf	4	1	4	3	0	0
Miñer, rf	4	0	2	3	0	0
Glass, 3b	3	0	0	3	1	0
Van Landingham, 2b	3	0	1	2	4	0
Carson, 1b	4	0	0	8	0	0
Wolgamot, c	2	0	0	1	0	0
Rodriguez, p	2	0	0	0	3	0
Readeap, c	2	0	1	2	0	0
Cannon, p	1	0	0	1	1	0
Walker, p	0	0	0	0	0	0
Totals	33	3	8	27	12	1

Score by innings: R

St. Louis100 004 030—8
Waco002 001 000—3

Home runs: Hornsby 2, Warwick. Two-base hits, Hornsby, Hafey, Davis. Stolen bases, Douthit. Struckout, by Myers 4, Keen 4, Huntzinger 1, Rodriguez 1, Cannon 1, Walker 1, Walked, by Myers 1, Keen 1, Rodriguez 1, Cannon 1. Hits, off Myers 5 in three, Keen 2 in three, Huntzinger 1 in three, Rodriguez 3 in five, Cannon 9 in three, Walker 1 in one. Runs, off Myers 2, Keen 1, Rodriguez 1, Cannon 7. Double plays, Hornsby to Thevenow to Bottomley 2. Time, 2:02. Umpires, Blackburn and Mails.

This is the box score from the game that Robert Lagunas played against Rogers Hornsby of the St. Louis Cardinals, when the Hall of Famer refused to shake his hand.

MEXICAN AMERICAN BASEBALL

YOUTH BASEBALL
FROM SANDLOTS TO
UNIVERSITY DIAMONDS

We were the Evergreen Comets, and we were champions of the world, East L.A., and everything else as we knew it. Evergreen was the name of our neighborhood, our street, our school, and our park. We had not been touched by real Little League, Babe Ruth League, Pony League or any of that, not yet. We just gathered at the park by the old backstop in the park, and whoever showed up, that was our team.

Evergreen was bordered by the under construction 60 East, "Flats" east of that, Brooklyn Avenue to the North, and Soto to the West. Brooklyn and Soto was the center of the world, but no one went there unless it was to go shopping with our mothers. We were content to hang out in the park or the street, and play baseball from morning till dark. We were undefeated champions. Sure we lost a few games, but it was always because the other side cheated, so, we didn't count them. We won all the big games; we even beat teams who had uniforms.

We were the Evergreen Comets, and we were champions of the world, East L.A., and everything else, as we knew it.

—Tomás Benitez, Evergreen Comets

Besides the sheer fun of playing and competing, baseball taught children the skills and lessons of playing a team sport—responsibility, cooperation, and competition. This experience was rarely taught in the schools to Mexican youth at the time. Moreover, these same skills and lessons contributed to establishing community solidarity, developing leaders, and imparting a sense of fair play, both on the field and in American society. Many of the ballplayers credited the countless managers and coaches for fostering and mentoring their education as athletes. Former ballplayers still remember the names and the profound impact that these extraordinary individuals had on their lives, not only on the diamond but also in their personal lives and in the workplace. Many players were inspired to give back to their community as coaches, teachers, and other public servants.

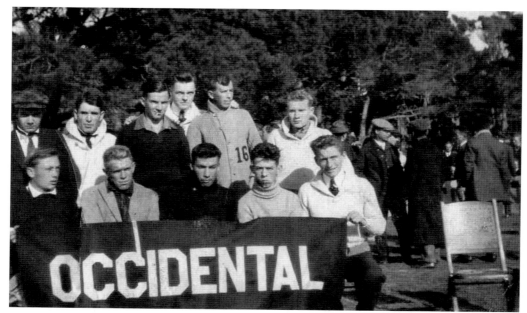

Efren A. Montijo was among the first Mexican Americans to play baseball at local Southern California colleges. He played for the Occidental College Tigers from 1914 to 1917. In the Occidental banner photograph above, Montijo appears in the center of the first row, and in the train picture of the team traveling to a game he is fourth from the left. Montijo was a star pitcher known as "the Mexican Marvel" and "the Mexican pitching phenom," according to the *Los Angeles Times.*

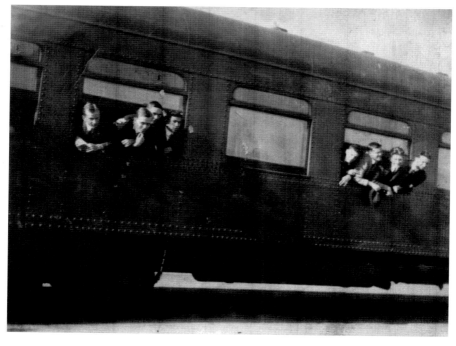

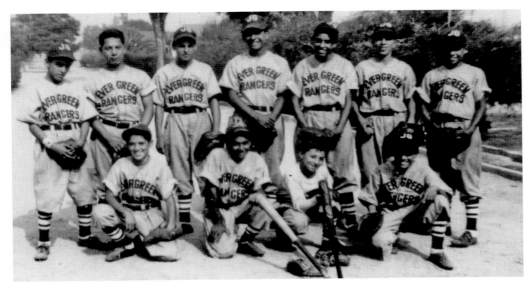

Most of the Mexican American high school and college players began playing baseball on youth teams and leagues in Los Angeles. Among the teams was the Evergreen Rangers, which had several outstanding players. One of those ballplayers was Al Padilla (second row, far right), who later starred at both Roosevelt High School and Occidental College. For the most part, youth teams had dedicated managers and coaches committed to mentoring youth.

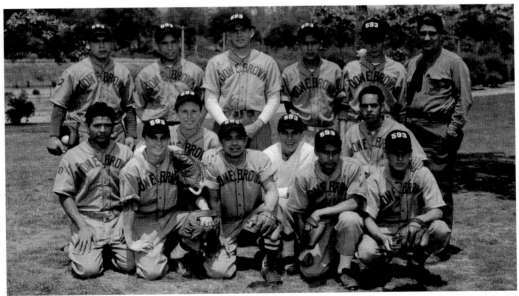

The American Legion Don E. Brown Post 593 baseball team of 1946 was a prominent youth club. The famous actor and comedian Joe E. Brown was a baseball fan and advocate for youth baseball. After losing a child, Brown sponsored teams in low-income areas in the name of his late son. This was especially important in East Los Angeles, where there were no Little League teams. Appearing in the photograph is coach Andrew Sais, dressed in a Boy Scout uniform.

MEXICAN AMERICAN BASEBALL IN LOS ANGELES

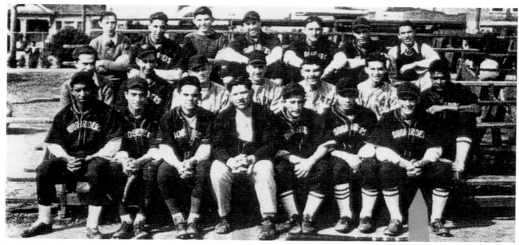

In 1932, Coney Galindo was the varsity baseball coach at Theodore Roosevelt High School in Boyle Heights, where he had a profound influence on a number of student-athletes, including Joe Gonzáles (first row, far left). He motivated many of his students to go on to college and was also responsible for mentoring many young ballplayers. Galindo was also one of the top high school baseball umpires in Los Angeles.

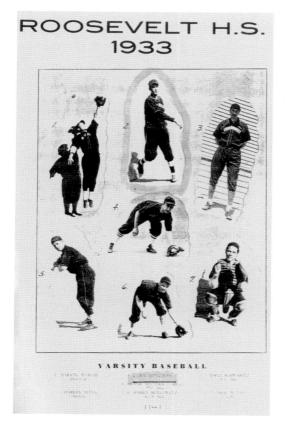

An outstanding player from the Los Angeles City schools during the 1930s was Joe Gonzáles. He was on the varsity team at Roosevelt High School in 1933 and played several positions, including pitcher. Roosevelt High School was a very ethnically diverse school during the 1930s and 1940s, but it would become a predominantly Mexican school by the early 1950s. Over the years, it has produced numerous collegiate and professional Mexican American ballplayers.

YOUTH BASEBALL

Several Mexican Americans from Los Angeles attended the University of California Los Angeles (UCLA). Among them was the "Spanish Tornado," Elías Baca, who played for the Bruins during the mid-1930s and became the first Mexican American teacher in his hometown of Casa Blanca, California.

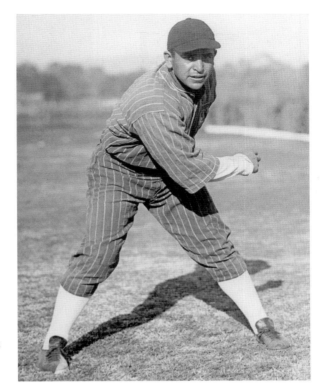

The 1934 UCLA baseball team poses here for a photograph. Elías Baca is in the second row to the far right.

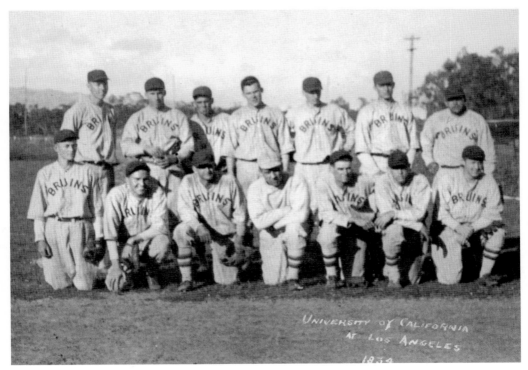

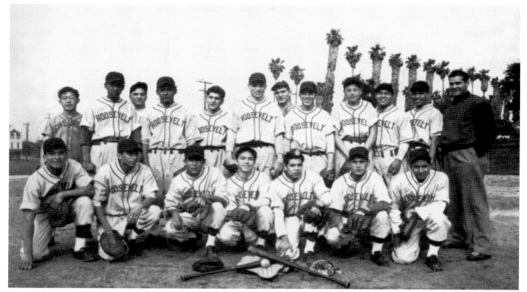

The 1940 Roosevelt High School varsity team included Joe Gonzáles (second row, far right) and Al Padilla (second row, second from the right). Gonzáles encouraged Padilla to enroll at Occidental College, because the local Southern California college was highly regarded in the coaching profession and would increase his chances of employment as a teacher and coach in the Los Angeles Unified School District. Padilla also wanted to play football and became the team captain. He made the All-Conference team for two years and was later inducted into the Occidental Tigers Football Hall of Fame.

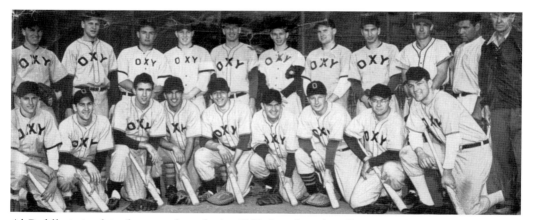

Al Padilla is in this photograph with the 1950 Occidental College baseball team (second row, second from the right, without a cap). He was the only Mexican American on the team when few students of color attended Occidental during the 1940s and 1950s. A former Garfield High School student playing baseball asked Al to go out for baseball. Padilla came out to practice and impressed the coaches; his first hit was a double with the bases loaded.

YOUTH BASEBALL

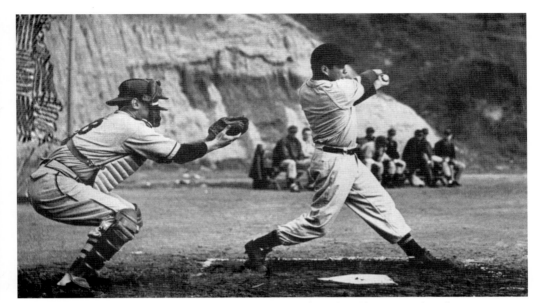

Al Padilla is pictured swinging at the plate at Occidental College. He played one year as a center fielder and sometimes as a pitcher. He later taught and coached both baseball and football at Roosevelt and Garfield High Schools in East Los Angeles. In 1960, Padilla became the first Mexican American head coach of a high school team in Los Angeles. He later became a legendary football coach at East Los Angeles Community College (ELAC).

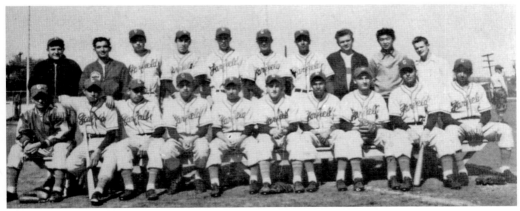

During the late 1940s and 1950s, Roosevelt High School's archrival, James A. Garfield High School, was a powerhouse, winning numerous city tournaments, conference titles, and city championships. Coach Robert "Bob" Holmes successfully guided the victorious Garfield Bulldogs. The 1949 team featured an outstanding pitcher, Charlie Mena (first row, second from the left). Mena won games against Wilson, Los Angeles, Roosevelt, Jordan, South Gate, Bell, Huntington Park, and other high schools.

The 1952 Garfield High School team was definitely of championship caliber, winning 18 consecutive games and only losing two contests during the season. The team's overall record was 24–2. Not only did they capture the Southern League title, but they went on to win the Los Angeles City Championship. Among the talented players were Joe Gaitan (left), and catcher Tom Robles (below). They were both selected for the all-city team.

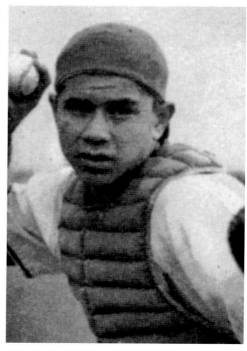

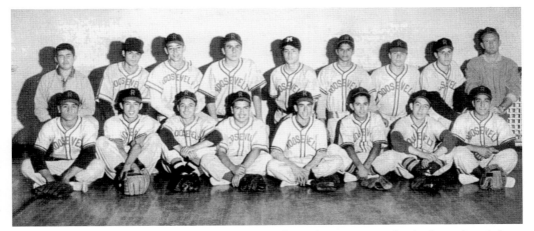

One of the greatest Roosevelt baseball teams was the 1954 varsity squad, which produced three future UCLA ballplayers: Art Velarde (first row, far right), Conrad Munatones (second row, fifth from left), and Ernie Rodríguez (first row, second from right). Another teammate, Armando Pérez (second row, fourth from left), was signed by the Baltimore Orioles organization in 1956 and assigned to the Vancouver Mounties, their minor-league affiliate in the Pacific Coast League.

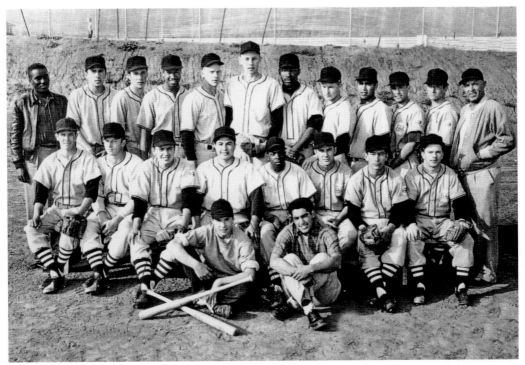

The East Los Angeles Community College baseball team of 1955–1956 included Art Velarde (first row, right, without uniform) and Ernie Rodríguez (second row, second from right). Both boys played at ELAC before enrolling at UCLA.

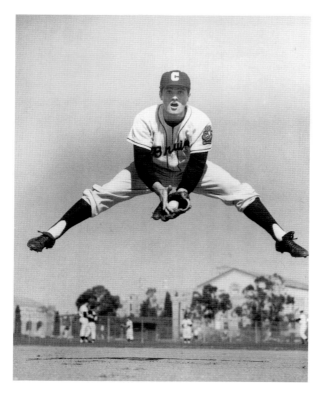

Roosevelt High School graduate and former class president Conrad Munatones's successful season at UCLA attracted scouts from the Los Angeles Dodgers. Munatones, seen here, signed a bonus contract to become the first Los Angeles–born Mexican American player to be signed by the Dodgers and played in their minor-league system. Upon completion of his baseball career, Munatones became an educator.

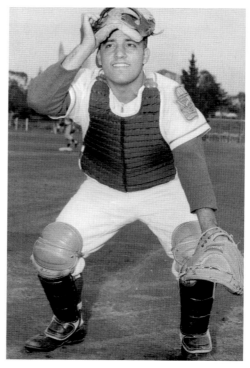

Catcher Art Velarde is pictured at Joe E. Brown Field at UCLA. He was one of the biggest stars to come out of Roosevelt High School. He played at Roosevelt from 1951–1954, at ELAC in 1955–1956, and at UCLA in 1957–1958 as a catcher.

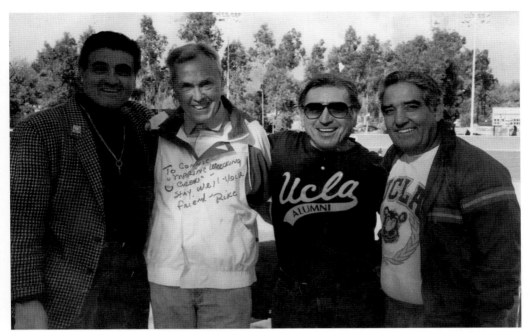

From left to right, Conrad Munatones, UCLA baseball coach Art Riechle, Ernie Rodríguez, and Art Velarde pose for a photograph.

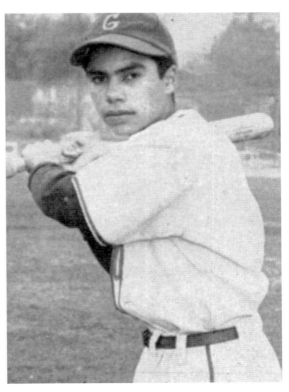

Garfield High School Native American and Mexican American baseball player Fred Scott competed against Art Velarde, Ernie Rodríguez, and Conrad Munatones in high school and college. He was offered a contract by the Boston Red Sox while he was playing for the Junior Red Sox. Teams like the Junior Red Sox were comprised of young players that the major-league teams groomed for the future. Scott decided to play at USC. He is posing here in his Garfield High uniform.

Fred Scott (second row, second from the right, next to the equipment manager) is seen above as a member of the 1959 USC baseball team. Scott is caught in action turning a play at second base in the picture below. He eventually signed with the Baltimore Orioles organization but did not advance in the minor-league system. He returned to USC and later attended California State College, Los Angeles (now California State University, Los Angeles), for his education.

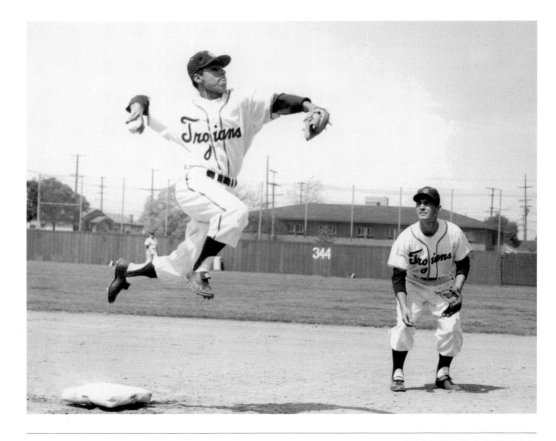

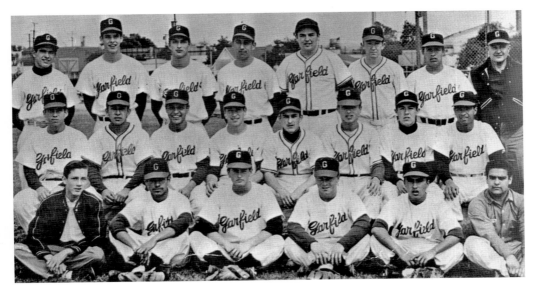

Raul Moreno (second row, second from right) starred on Garfield High School's Los Angeles City Championship team of 1956 and secured a baseball scholarship to attend Humboldt State College. The image at right shows Moreno taking batting practice at Humboldt inside the stadium named the Redwood Bowl.

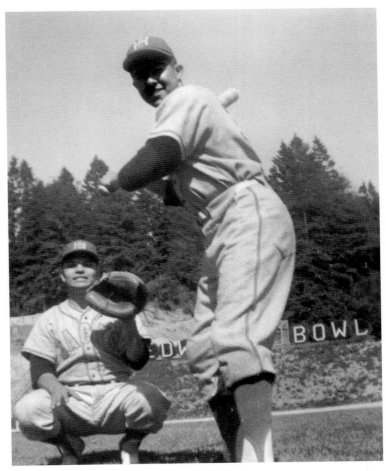

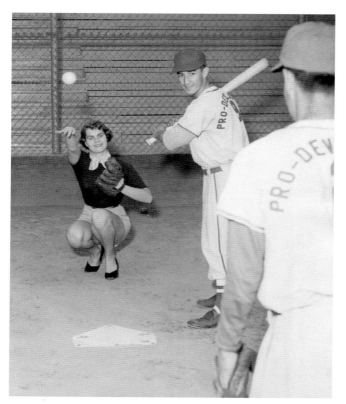

Son of Robert "Lakes" Lagunas, Bob Lagunas followed in his father's footsteps by becoming an outstanding player in his own right. Bob, who grew up in Pío Pico (now called Pico Rivera), tried to play baseball as much as possible. At left, he is at bat for the Pro-Development Community team, and below he poses as a member of the Pico youth club (second row, far left).

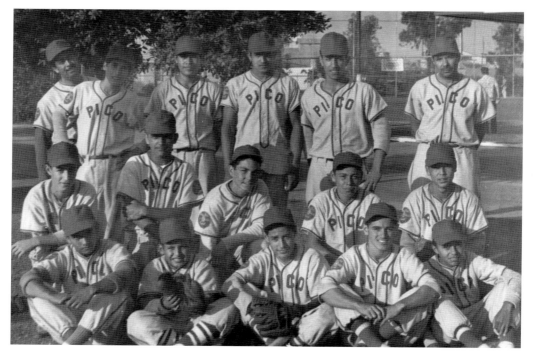

YOUTH BASEBALL

Bob Lagunas starred on the California State College, Los Angeles team from 1959 to 1961. He ended the season of 1959 with a .359 batting average and was hitting over .400 for most of the season. Lagunas also was selected in 1960 to the All-Conference baseball team. During this time, the team used Brookside Park in Pasadena as its home diamond and emerged as a formidable challenger to older and larger universities, including USC and UCLA.

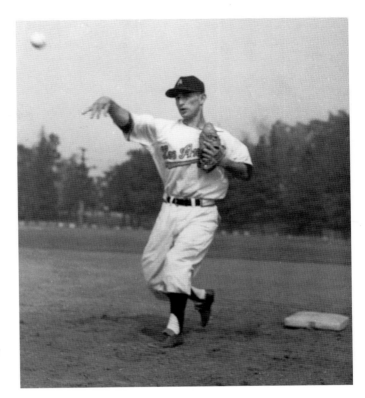

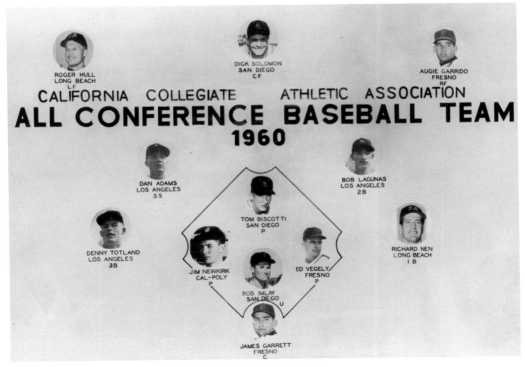

ROGER HULL
LONG BEACH
LF

DICK SOLOMON
SAN DIEGO
CF

AUGIE GARRIDO
FRESNO
RF

CALIFORNIA COLLEGIATE ATHLETIC ASSOCIATION
ALL CONFERENCE BASEBALL TEAM
1960

DAN ADAMS
LOS ANGELES
SS

BOB LAGUNAS
LOS ANGELES
2B

TOM BISCOTTI
SAN DIEGO
P

DENNY TOTLAND
LOS ANGELES
3B

JIM NEWKIRK
CAL-POLY
P

ED VEGELY
FRESNO
P

RICHARD NEN
LONG BEACH
1B

BOB IMLAY
SAN DIEGO
U

JAMES GARRETT
FRESNO
C

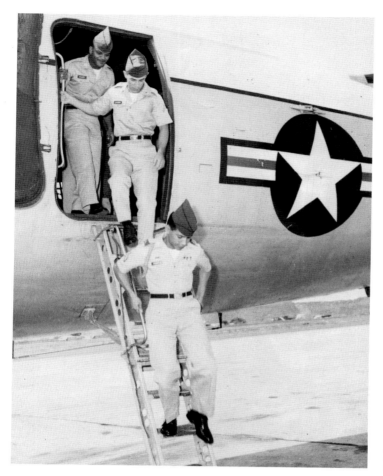

Several Mexican American baseball players were on military service teams while serving their tours of duty. Many men enjoyed their playing days in the service, including Bob Lagunas. At left, Lagunas is in the middle of the three men shown arriving by plane to play a game. In the photograph below, he stands in the first row, second from the right, on the Fort Clayton club. Fort Clayton was the U.S. Army base in the former Panama Canal Zone.

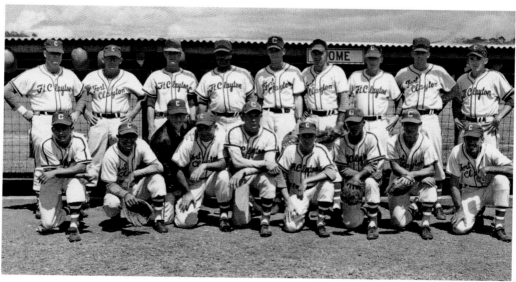

OY – BEISBOL INTERNACIONAL – HOY

F. D. del G. ESTADIO MODELO GUAYAQUIL

(Avenida de las Américas)
3 P. M. SENSACIONAL REVANCHA

"ALL STARS"

(con los mejores jugadores de las Fuerzas Armadas de los Estados Unidos
de la Zona del Canal)

vs.

SELECCION DEL GUAYAS

(con sus valiosos exponentes)

PRECIOS: Entrada a Palco Numerado $ 25.—
 Tribuna $ 15.— Damas y Niños 10.—
 General 5.— Damas y Niños 3.—
BOLETOS A LA VENTA HASTA LA UNA DE LA TARDE EN EL LOCAL
DE LA PISCINA OLIMPICA Y DESPUES EN LAS VENTANILLAS DEL ES-
TADIO MODELO GUAYAQUIL.-

A newspaper advertisement promotes a baseball game between the U.S. Armed Services of the Panama Canal Zone and Selección del Guayas. Guayas is a coastal province in Ecuador.

The military all-star team selected to play against El Salvador, Costa Rica, Panama, and Ecuador pose for a photograph. The team included two Mexican Americans as well as three Puerto Ricans. Bob Lagunas was a member of this team (first row, second from right) and recalled the diversity of Latin cultures and the variation in the Spanish dialects.

Johnny Peña of the Peña brothers traveled through Europe playing baseball during his tour of duty.

YOUTH BASEBALL

Bob Lagunas continued his career in baseball by coaching the St. Francis High School team in La Canada-Flintridge, as well as serving as a head baseball coach for the freshman team at Cal State L.A. Lagunas was also one of the commissioners for the Los Angeles County Baseball Association from 2001 to 2005. Like many of his generation, Lagunas dedicated his life to promoting youth baseball.

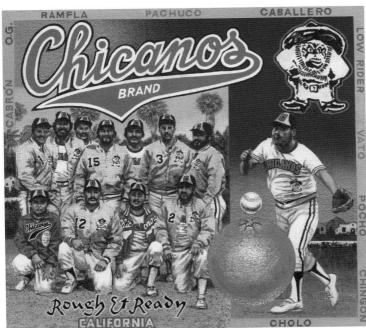

Chicanos Brand by artist Ben Sakoguchi pays tribute to youth baseball, particularly the efforts of longtime Southern California manager and promoter Jim "Chayo" Rodríguez of Corona, California. Like other Mexican American coaches, Rodríguez saw baseball and softball as ways of keeping youth out of gangs and focused on productive lives. (Courtesy of Ben Sakoguchi.)

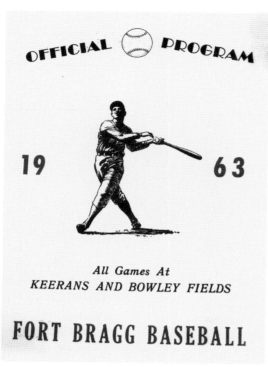

OFFICIAL PROGRAM

19 63

All Games At
KEERANS AND BOWLEY FIELDS

FORT BRAGG BASEBALL

Many Mexican Americans from Los Angeles played baseball while serving in the military and appeared in the Fort Bragg baseball program. These baseball players entertained and boosted the spirits of their fellow soldiers by playing a game most soldiers had enjoyed as boys.

One of the many Mexican Americans from Los Angeles who played military baseball was Art Lagunas, seen here on the right. He also was an outstanding shortstop in high school, community college, and at L.A. State College.

YOUTH BASEBALL

3

BARRIO BASEBALL
A CELEBRATION OF ATHLETIC
TALENT AND ETHNIC IDENTITY

Baseball in the Mexican quarter of Los Angeles brought together many Mexican families for weekly gatherings. This was especially true during the 1940s and 1950s when television had yet to make its mark; a time when many newly arrived Mexicans firmly clung to the cultural ties that assured them of security, and a time when only minor-league baseball existed in Los Angeles. A routine Sunday consisted of church and breakfast in the morning and baseball in the afternoon. It did not matter if one was a baseball fanatic or not, baseball in the barrios was a tradition.

—Samuel Regalado
"Baseball in the Barrios: The Scene in East Los Angeles Since World War II"
Baseball History, summer 1986

The Sunday afternoon games of barrio baseball attracted large crowds, sometimes in the thousands, to view semipro and municipal league teams throughout Southern California. During the 1920s and 1930s, the Spanish American League fielded a number of Mexican American teams: the San Fernando Merchants, Ortiz Fords, Aztecas, and Santa Monica Los Tigres. Especially competitive and highly popular during this time were the El Paso Shoe Store and the Mexico baseball clubs.

By the 1940s and 1950s, other talented teams emerged, such as the Eastside Merchants, National Auto Glass Company, Eastside Beer, CIO Electrical Union Local 67, and Ornelas Market. Especially successful was the Carmelita Provision Company Chorizeros. The games played by these teams provided the Mexican community, as well as the larger American society, with a special venue for affirming ethnic identity and cultural practices along with demonstrating athletic skill and baseball talent.

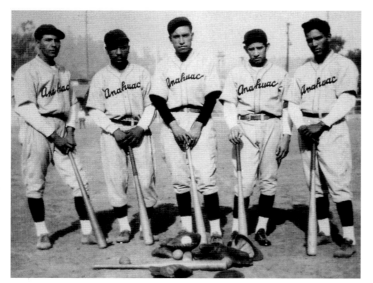

Mario López, a major figure of Mexican American baseball, both as a player and owner, began his career playing for several teams in Mexico. López (second from right) was an enthusiastic and outstanding athlete in his native Chihuahua, playing well enough with the Anahuac team to be recruited by the Cleveland Indians in 1925 when he was only 16 years old.

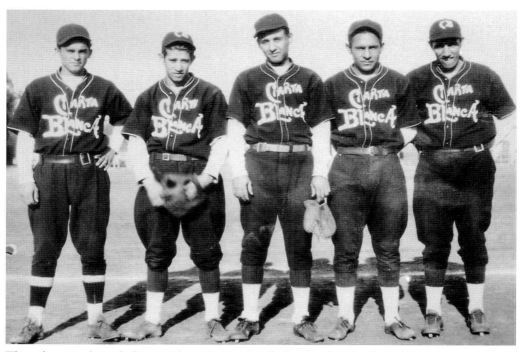

This photograph includes two legendary individuals who largely shaped Mexican American baseball in the greater Los Angeles area: Mario López (second from left) and Tommy Pérez (far right). Both of these formidable players forged a friendship that endured for years. They were teammates for Carta Blanca, and later they played together for both Mario's Service Station and Carmelita Provision Company, two companies owned by López and managed by Pérez. Their enduring friendship was common among former players. Even today, after 60 years, many former players remain friends and still gather together to reminisce about their days on the diamond.

BARRIO BASEBALL

BASE BALL GAME
For The Champion Ship
Of The
"SPANISH-AMERICAN LEAGE"
SUNDAY FEBRUARY 24th 1929 AT 1 P. M.

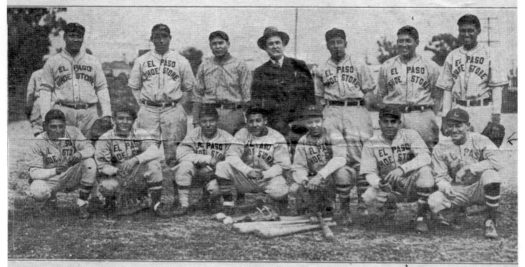

EL PASO SHOE STORE VS San Fernando MERCHANTS
AT THE "WHITE SOX PARK"
38th and Ascot Ave. Take "B" Car
Two Games for the Price of One
FIRST GAME WILL START PROMPLY AT 1 P. M.
First Ball will be pitched by the Mex. Consul Mr. F. A PESQUEIRA
and cought by Mr. BERT COLIMA with
Mr. CABALLERO HUARACHA at bat

This handbill is announcing a game between the El Paso Shoe Store and San Fernando Merchants, popular archrivals in the Spanish American League. The El Paso Shoe Store had its home field in San Gabriel, but the crowds were so enormous that the larger venue of White Sox Park in Los Angeles often became the site of games. The Mexican consul and prominent celebrities frequently attended the games.

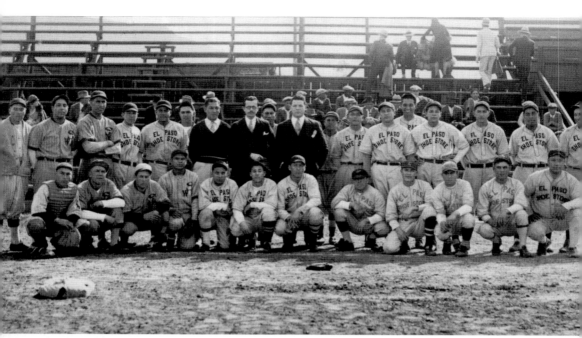

The El Paso Shoe Store, Mexican consul Rafael de la Colina (center, wearing eyeglasses with the mustache), and four players from the San Fernando Merchants pose at White Sox Park in 1928. Manuel Regalado was the manager of the El Paso Shoe Store, which often played Anglo teams such as the Cudahy Puritans and Torrance Blues, as well as the Japanese American community's highly successful Los Angeles Nippons.

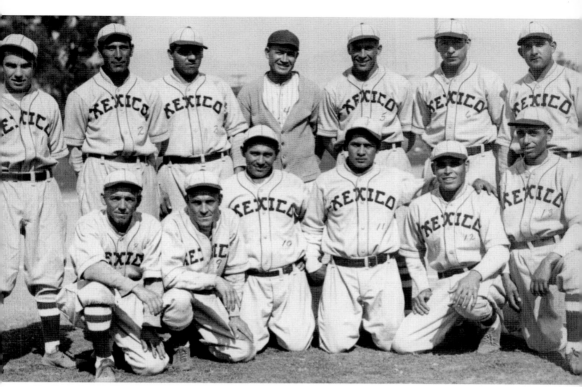

Manuel Regalado (second row, fourth from left) also managed the Mexico baseball team of 1930, owned by Julio Pérez.

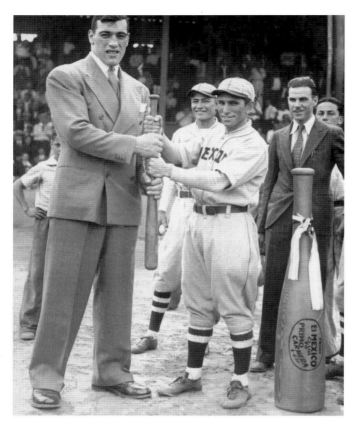

Former Italian heavyweight boxing champion Primo Carnera poses with the Mexico baseball team at White Sox Park in 1930. Also in the photograph are manager Manuel Regalado, coach Joe Pirrone (holding bat), and team sponsor Julio Pérez (right).

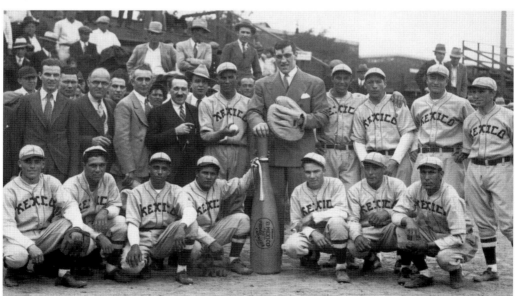

The Mexico baseball club of 1930 gathers here around Italian heavyweight boxing champion Primo Carnera at White Sox Park.

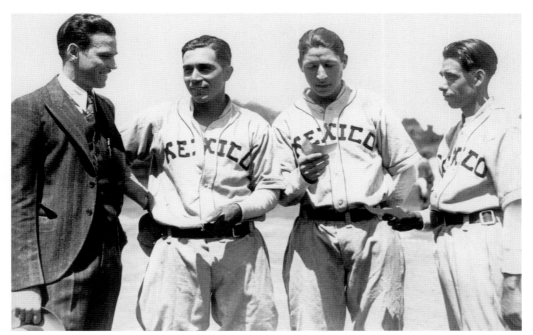

Stars of the Mexico team are pictured here at White Sox Park in 1930 with sponsor Julio Pérez (left). From left to right they are Trujillo, Alvarez, and Díaz.

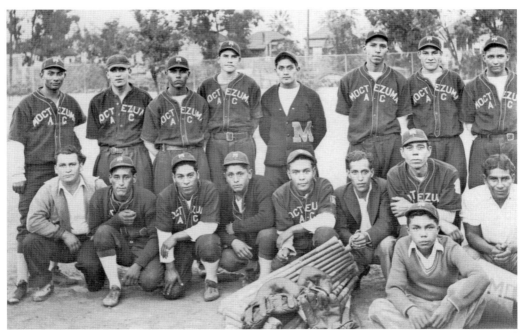

The Moctezuma baseball team included Lalo Regalado and Adolfo Regalado, brothers of prominent baseball manager and promoter Manuel Regalado, seen here in Downey Park, Los Angeles, in 1931.

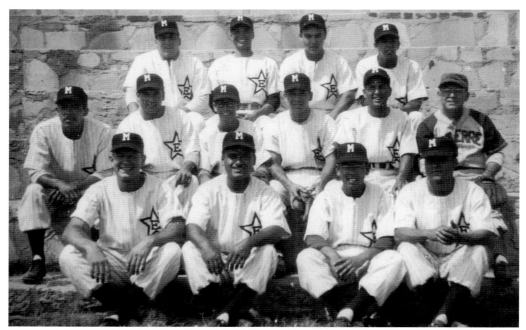

Baseball teams mushroomed in the Mexican community during the post–World War II period. The Eastside Merchants represented a group of businesses that pooled their resources to support a single team. Generally the merchants were responsible for purchasing the uniforms, equipment, gas for travel, food and beverages, trophies, and team photographs.

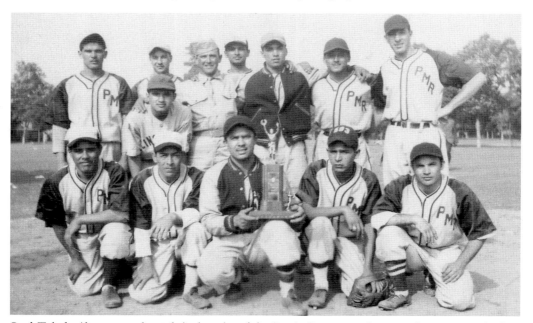

Saul Toledo (front row, far right) also played for Pete's Crate, another popular team in the Los Angeles Municipal Leagues.

BARRIO BASEBALL

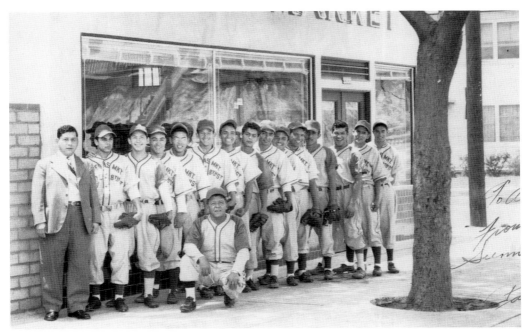

This photograph of the Ornelas Market team includes store owner Mr. Ornelas (far left, in the suit). Most of these teams lasted two to three years. Even though sponsorship or financial support was critical for the success of any local team, the teams were regarded as a way to keep boys out of trouble and from joining gangs. A number of managers had multiple sons on their teams in order to keep their children out of harm's way.

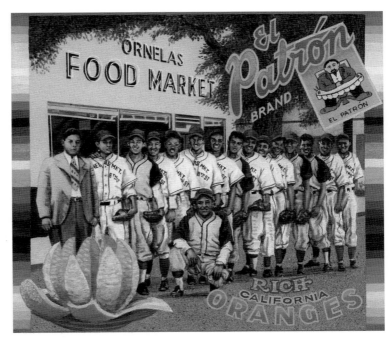

El Patrón Brand (the Boss) by artist Ben Sakoguchi is based on the Ornelas team photograph and underscores the sponsorship of baseball teams by local businesses in the Mexican community. (Courtesy of Ben Sakoguchi.)

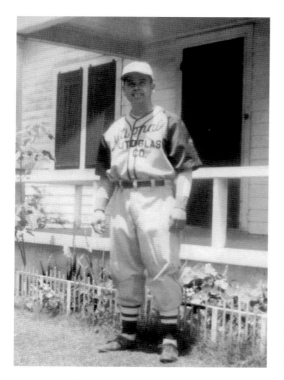

The National Auto Glass Company baseball team of the early 1940s is shown here. It includes Ray Armenta, a talented third basemen, appearing at his home (left) and Manuel "Shorty" Pérez (below, first row, third from left) and Armenta (below, second row, far right) with the team. Pérez was famous not as a player but as a manager. Most of the best players wanted to play for him because of his vast knowledge of the game and his talent at running winning teams. Many players would gladly jump from a good team to be on an outstanding team.

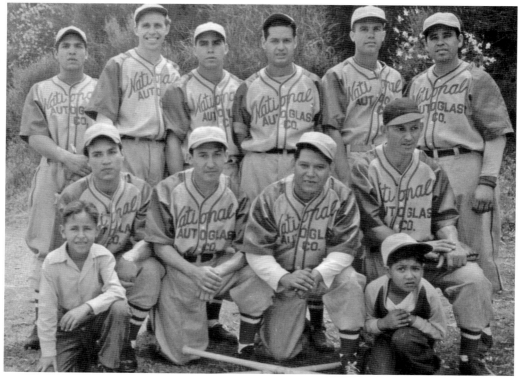

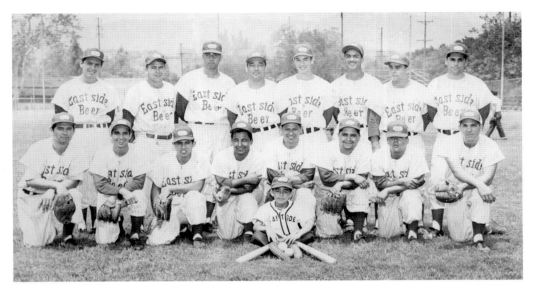

The 1951 Eastside Beer team continued for about four years before the club was disbanded when the brewery went out of business. At the age of 17, Ernie Blanco (bottom row, third from the left) was one of the younger players.

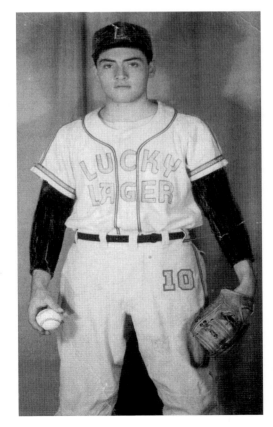

In 1953, sixteen-year-old Conrad Munatones played for the barrio team Lucky Lager Beer while attending Roosevelt High School. Munatones would later play college baseball at UCLA and professional baseball in Canada.

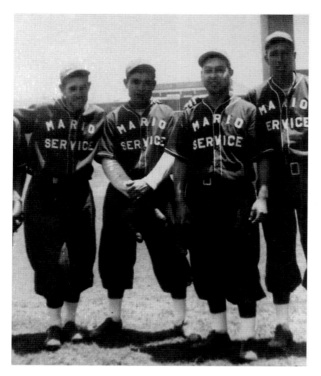

In 1942, Mario López (far left) decided to sponsor a team under the name of his business, Mario's Service Station. The team had several excellent players, in part because López gave them free gas when they played an outstanding game. Tommy Pérez (far right), López's longtime friend, first managed the team. This photograph shows the team playing against the Pacific Coast League Angels at Wrigley Field in Los Angeles.

A baseball dynasty in East Los Angeles began with a committed business owner and baseball fan by the name of Mario López. An avid ballplayer in Chihuahua, Mexico, before immigrating to the United States, Lopez was recruited by the Cleveland Indians. However, his family would not permit him to turn professional. Unable to pursue a pro baseball career, López became an ardent sponsor of East Los Angeles baseball. López (left) is pictured here with Tommy Pérez, an outstanding player during the early years of the Carmelita Provision Company team. López opened a Mexican meat factory specializing in pork and sausage items on Carmelita Street. His team was called the Carmelita Provision Company, or CPC.

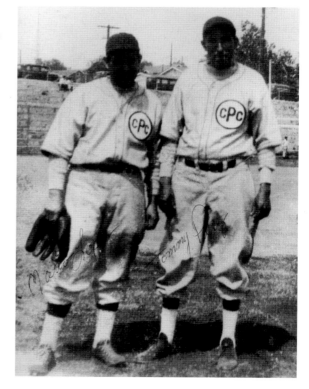

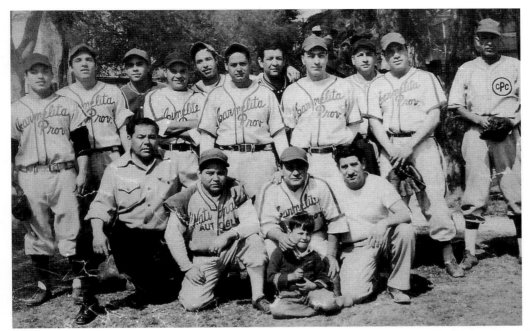

The Carmelita Club, owned by Mario López, (first row, far right) and managed by Shorty Pérez (first row, second from left) was one of the greatest barrio teams of Los Angeles. Unlike other teams lasting only a few seasons, the CPC would last years, eventually earning the moniker Los Chorizeros (the sausage makers). From the 1940s to the 1970s, the Carmelita Provision Company Chorizeros are said to have won as many as 19 Los Angeles City Championships.

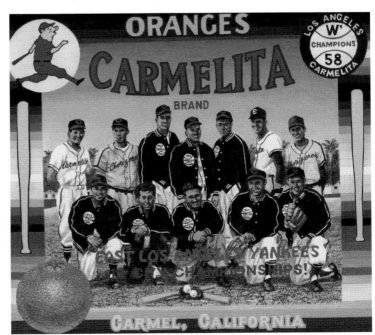

Carmelita Brand by artist Ben Sakoguchi honors Mario López's "sausage makers," who became the dominant Mexican American community team for decades. (Courtesy of Ben Sakoguchi.)

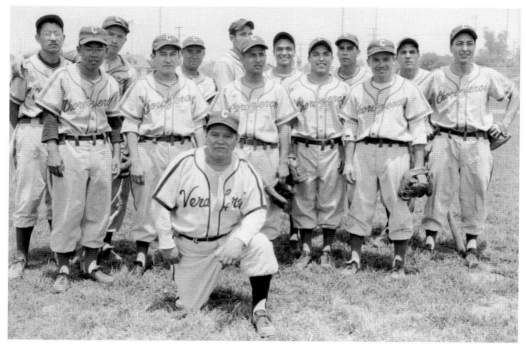

Long before "Fernandomania" and the appearance of Los Angeles Dodgers pitcher Fernando Valenzuela, there was "Chorizeromania" among Mexicans and Mexican Americans throughout Los Angeles. Kneeling in front in this early photograph of the Chorizeros is Shorty Pérez. His Veracruz uniform was from a former city municipal team named after a Mexican restaurant. The Chorizeros played their games before large crowds, usually on Sunday at Fresno, Belvedere, and Evergreen Parks in East Los Angeles. Former players vividly remember preparing the fields and wearing wool uniforms. Spectators sat on the grass or in makeshift stands to watch games with homemade lunches. The umpire was behind the pitcher, and balls occasionally landed in swimming pools. Only two balls were used for entire games, and the winning team took them home.

Standing in front of his home is Ray Armenta in the mid-1940s. He was among the outstanding players who wore the Chorizero uniform and went on to play college and professional baseball. Armenta lived in southwest Los Angeles, a distance from Evergreen Park in East Los Angeles, but neither distance nor injuries ever prevented him from playing. Armenta was employed by Carmelita in the early 1950s, one of several baseball players who worked for the company.

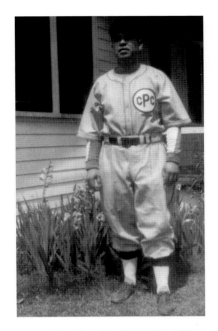

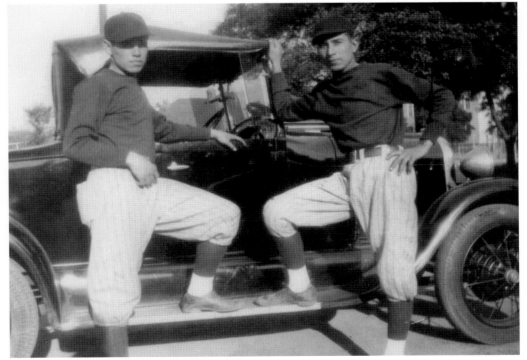

Ray (left) and Joe Armenta lean on a Ford Roadster in Los Angeles. Joe played baseball with his four brothers for a short period of time, hoping to acquire their same passion and competitiveness for the game. He eventually moved to Tucson, Arizona, while his brothers Paul, Ray, Tony, and Oscar continued playing in Los Angeles.

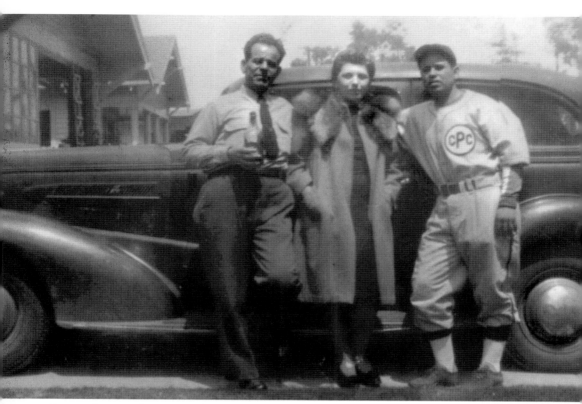

Prior to leaving for a Carmelita Provision Company game in 1946, Ray Armenta (right) poses with his wife, Teresa de la Fuente, and his brother Paul. In 1932, Paul played baseball with his brothers for the Alianza Mexican baseball team in Los Angeles but discovered his passion was umpiring. He was a minor-league umpire for 20 years and also officiated games in Mexico.

Ray Armenta is seen here swinging a bat and fielding a ball. Armenta was a versatile player at several positions, including first base, third base, and occasionally catcher. He was a switch hitter, and his specialty was drag bunting in addition to challenging umpires' decisions. His passion and competitiveness continued on the field for 40 years into the mid-1950s.

Saul Toledo played with Carmelita from 1947 to the early 1950s and is credited with coining the name "Chorizeros." Toledo not only played for the team, but he helped promote it by writing newspaper articles for the local press and serving as a public-address announcer. Toledo, a frequent master of ceremonies at Carmelita events, is seen in the photograph below raising a trophy between manager Shorty Pérez (left) and owner Mario López. Toledo recalled that the majority of teams the Chorizeros played were composed of Mexican Americans, but there were also teams comprised largely of African Americans or Asian Americans, reflecting the ethnic diversity of the greater Los Angeles area.

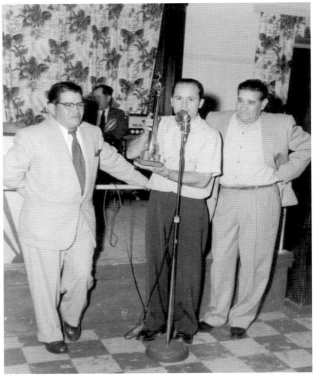

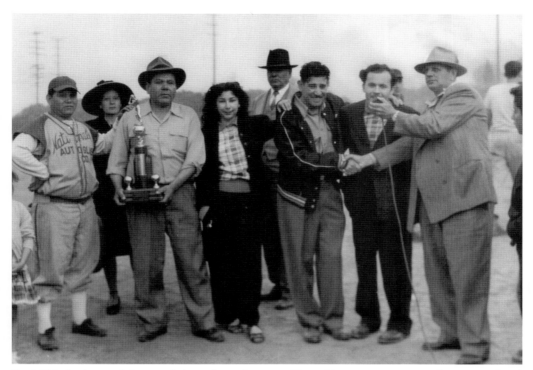

Saul Toledo (second from right) performed as a public address announcer and at many local barrio awards ceremonies. In the picture below, Toledo is attempting to teach his young son Saul Jr. how to bat.

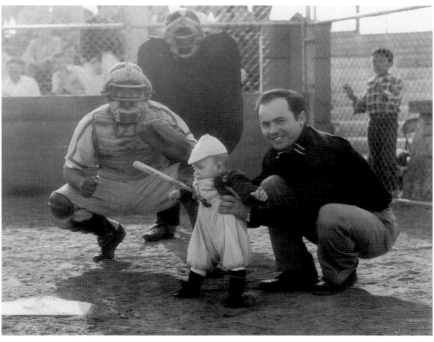

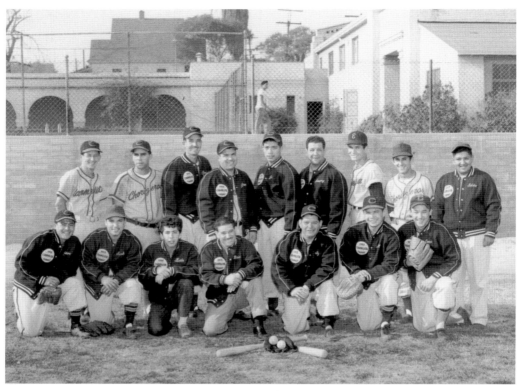

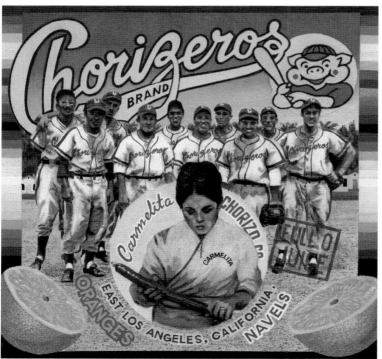

Above is a photograph of the 1953 Chorizero championship team with owner Mario López (first row, fourth from the left) and manager Shorty Pérez (first row, third from the right). At left, *Chorizeros Brand* by artist Ben Sakoguchi is a rendition of the Carmelita Chorizeros of East Los Angeles. (Courtesy of Ben Sakoguchi.)

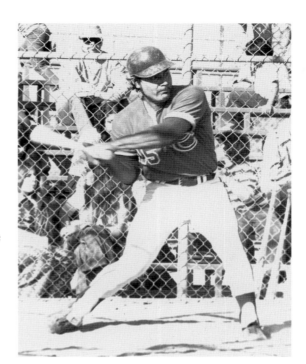

One of the great Chorizero players of the later years was Isidro "Chilo" Herrera, a power-hitting third baseman. Herrera also played in the Mike Brito Leagues and the professional leagues in Mexico. Below, Herrera is shown receiving the Most Valuable Player Award from famous baseball scout Mike Brito.

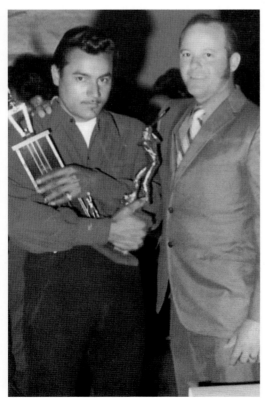

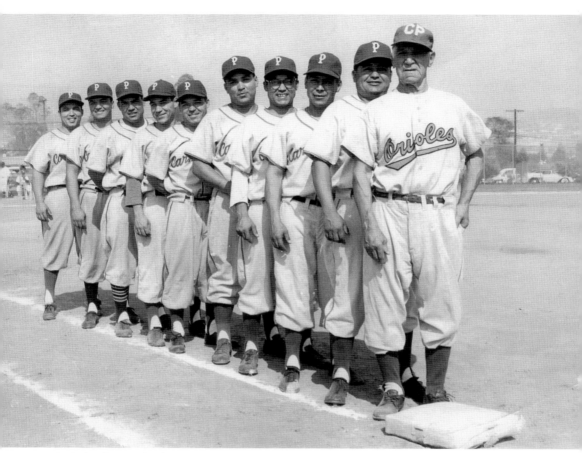

At Belvedere Park, the nine Peña brothers pose with their father, William Peña. This baseball family encompassed three generations, as grandfather, father, and all nine sons were baseball men. The grandfather, father, and five of the sons played the position of catcher. The "P" on the cap stands for Peña as well as the Carmelita Provision Company Chorizeros.

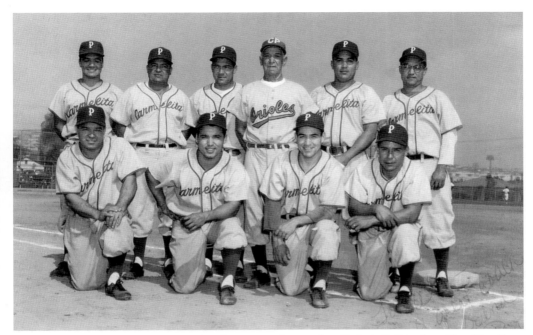

This photograph of the nine Peña brothers was submitted to *Ripley's Believe It or Not*. The Peña brothers fondly recalled the appreciation expressed to them by fans who regularly attended their Sunday games.

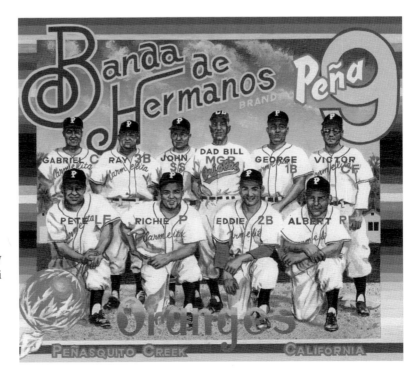

"*Banda de Hermanos Brand*" (Band of Brothers) by artist Ben Sakoguchi commemorates the nine Peña brothers and their father, Bill. (Courtesy of Ben Sakoguchi.)

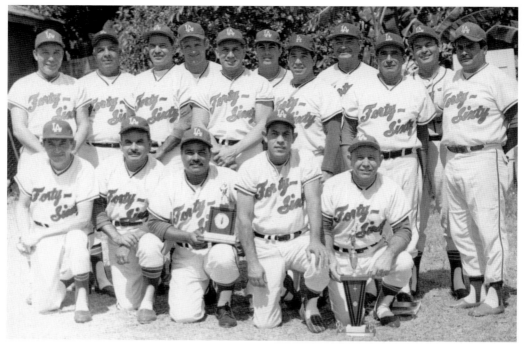

The Forty-Sixty baseball club also played local Southern California teams and was highly competitive. Many former barrio and ex-professional players refused to quit the game when they aged, instead opting for the Los Angeles Forty-Sixty Club of veterans. The Forty-Sixty won the 1968 Municipal Los Angeles Baseball League Championship.

Barrio teams extended beyond the east side of Los Angeles to other local Southern California barrios. Especially prominent was neighboring El Monte in the San Gabriel Valley, where the softball team Los Caballeros was from the barrio of Hicks Camp. (Courtesy of the La Historia Society of El Monte.)

TRANSNATIONAL BASEBALL
MEXICAN AMERICANS
PLAYING MEXICAN BASEBALL

I attended many Mexican baseball games during the thirties with my uncles Heberto and Eduardo Balderrama at White Sox Park in Los Angeles. They were mostly with teams from Sonora and Sinaloa. When extra balls were needed so as to continue the game, they would ask the public for contributions toward them.

—Francisco Balderrama Ruiz
correspondence to the authors, July 25, 2010

I remember traveling to El Paso, Texas, with the Forty-Sixty Club to play in El Paso, and relatives and friends would come over from Ciudad Juárez, Mexico, to see the game. Then there was the dance afterwards.

—Ron Regalado, Forty-Sixty Club Batboy
interview with the authors, July 21, 2010

Playing and viewing baseball served to promote Mexican American bonds to the Mexican nation. The hosting of teams from Mexico, as well as traveling to Mexico to play, frequently renewed relationships for family and friends across the border. Baseball in Mexico also provided an opportunity to play on a level playing field. It was an escape from the racism and discrimination that Mexican and Mexican American ballplayers experienced on and off the field in the United States.

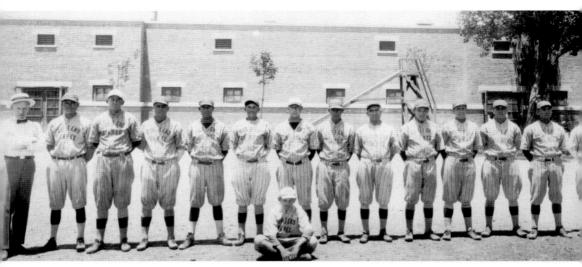

After retiring as a player, Manuel Regalado organized and managed several successful teams in Ciudad Juárez, Mexico, and El Paso, Texas, such as Juárez O'Brien Greenlegs in 1921.

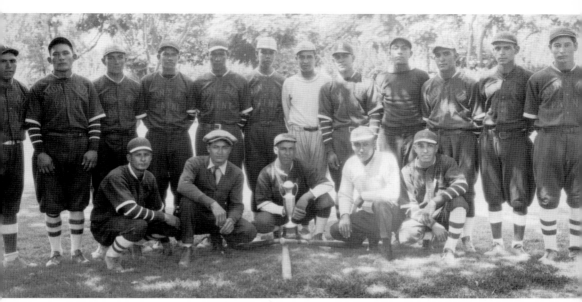

Baseball promoter Manuel Regalado organized Ramón's Auto and Paint in El Paso, Texas, in 1924. After arriving in Los Angeles in 1926, he began to enjoy even greater success. He was so notable that the Los Angeles Spanish language newspaper *La Opinión* frequently called Regalado the mastermind and the Mexican "McGraw" of local Mexican American baseball—a reference to the famous New York Giants Hall of Fame manager John McGraw.

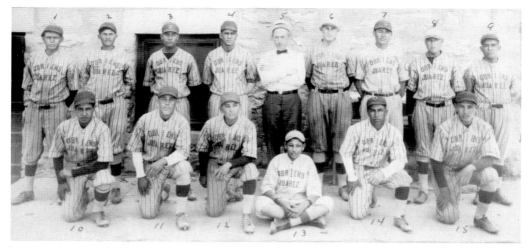

Jimmie O'Brien (second row, center) and Manuel Regalado (second row, third from right) continued as the sponsor and manager, respectively, of the Juárez O'Brien Greenlegs baseball team in 1923. They are pictured here at the Beal School in El Paso, Texas.

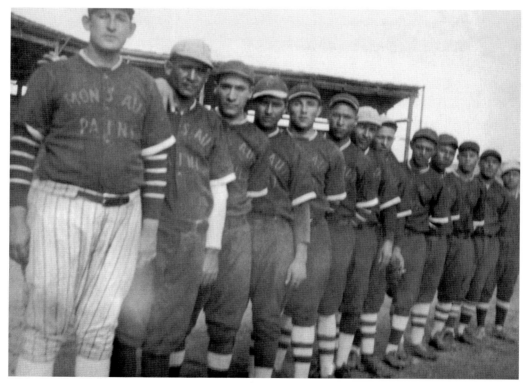

Ramón's Auto and Paint baseball team often traveled to the interior of Mexico for games, including Chihuahua, Mexico, where this photograph was taken in the 1930s.

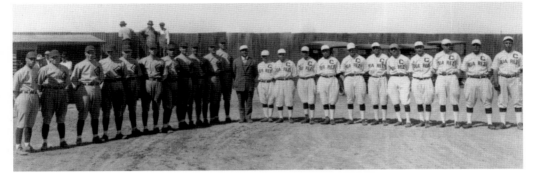

Southern California resident Robert "Lakes" Lagunas (above, far left) played for the El Paso baseball team in the Texas–New Mexico League during the 1920s. He described Texas as "still fighting the Battle of the Alamo" and remembered racial discrimination from the opposition teams and fans. Even though Lagunas was an outstanding shortstop with large legs, arms, and hands that were strong, his own minor-league teammates treated him as an outcast at times. He most enjoyed the games with Mexicans and particularly the team from Ciudad Juárez.

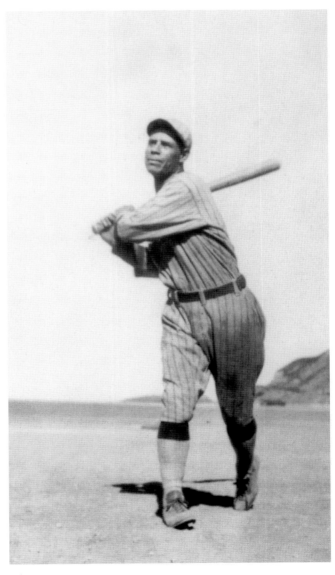

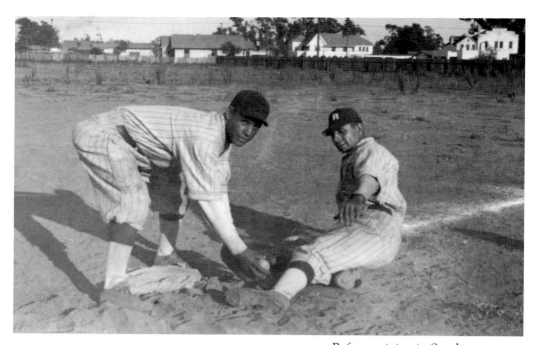

Before arriving in Southern California, Robert Lagunas (above, with glove) traveled the American Southwest during the 1920s and played for Jerome, New Mexico, in the Texas–New Mexico League, where he (pictured at left, to the right) experienced prejudicial treatment.

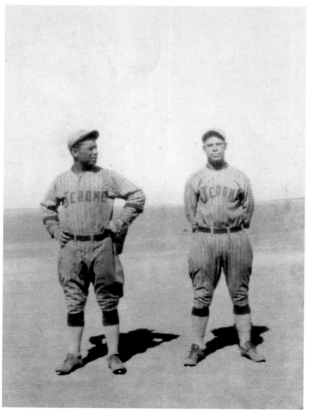

LAKES LAGUNAS

Lakes Lagunas, now the property of the Mexia baseball team, is playing brilliant baseball for the Gushers. Lagunas is a brilliant shortstop, and a fair hitter. He is young, anxious to succeed in the baseball world, and he may go higher. In spring training with the Cubs, Lagunas demonstrated that he was a conscientious performer, and a coming star, though lacking experience, which was but natural, for he is very young. Baseball fans as a rule are rather unjust. Lagunas is generally made the target of abuse by fans of rival cities when playing away from home, which is very unfair, unjust, and does not smack of the best of sportsmanship, but if the Mexia fans prove kind to Lagunas, are liberal in their applause of his many sensational plays, they may some day be more than glad that he played with the team. Under ideal conditions, Lagunas may battle his way to higher things in the baseball world, and that will be profitable to the Mexia club-owners. He certainly has the ability, and the higher he goes the easier it will be for the El Paso youngster.

An undated and unnamed newspaper article documents the abusive treatment targeted at Robert Lagunas during his playing days in the Texas–New Mexico League during the 1920s.

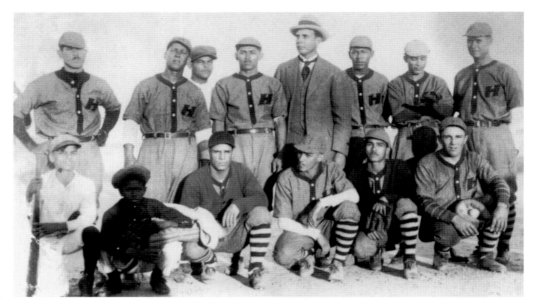

Growing tired of the racism in Texas and New Mexico, Robert Lagunas went to Mexico and played under his grandmother's last name, Gonzáles. When a player was under contract with one team but played for another under a false name, it was known as "outlaw baseball." In this 1928 photograph of the Hermosillo, Mexico, team, Lagunas squats in the first row, third from the left.

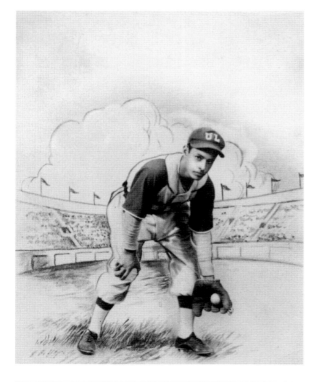

After moving his family to the Los Angeles area, Robert Lagunas decided to play in Mexico, where there was not the racial discrimination he had faced in Texas. He is pictured wearing a cap stitched with "UL" for Algodoneros del Union Laguna (the Cotton Pickers of United Laguna), a team representing the Laguna area of Mexico, which includes the cities of Torreón, Gómez Palacio, and Lerdo.

TRANSNATIONAL BASEBALL

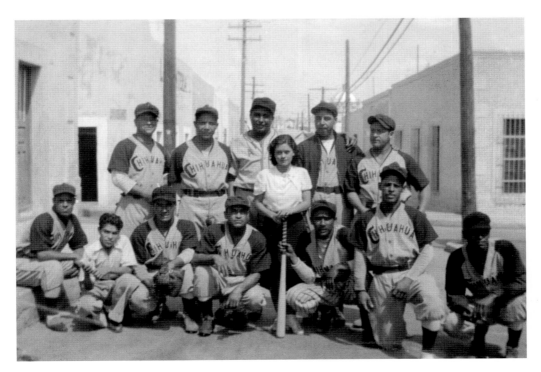

While his family was living in Southern California, Robert Lagunas traveled to Mexico to play for a number of Mexican baseball teams that were quite popular in the 1930s and 1940s. In the 1939 picture above is a team representing Chihuahua; Lagunas is in the first row at the far left. Below is the 1941 Chihuahua baseball team, featuring Lagunas in the first row, fourth from the left. Lagunas's brother Raymond also played for Chihuahua teams.

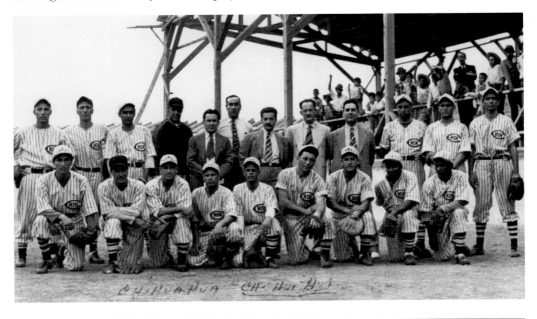

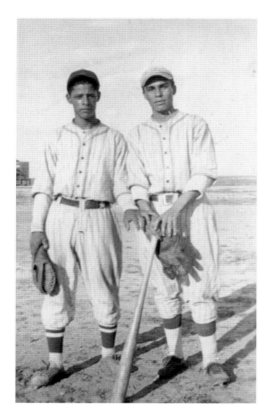

At left, Raymond Lagunas (left) appears with a fellow ballplayer in Mexico. Below, brothers Robert (right) and Raymond Lagunas are seen out of their baseball uniforms. They both enjoyed playing baseball and living in Mexico. They felt that, as athletes and persons, they were respected more in Mexico than in the United States. Raymond also married a Mexican woman.

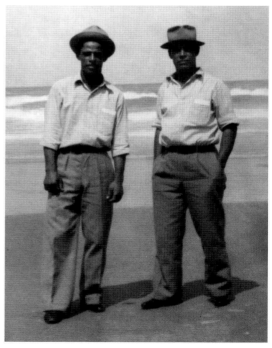

After playing baseball on El Monte teams for the Los Angeles County League during the 1950s, Rudy Viera, cousin of the Lagunas brothers Robert and Raymond, played for Chihuahua in the Mexican League.

EL CLUB DE BEISBOL

DE NUEVA ROSITA, COAH., MEXICO

Se enfrentará en un Juego de Beisbol al

CLUB 40-60

DE LOS ANGELES

El Sábado Julio 21 de 1973 en el Parque Hazard de la Calle Playground. A dos Cuadras atrás del Hospital General

EL JUEGO DARA COMIENZO A LA 1:30 P.M.

This newspaper advertisement announces a baseball game between the Forty-Sixty Club and the Baseball Club of Nueva Rosita, Coahuila, Mexico, at Hazard Park in Los Angeles on July 21, 1973.

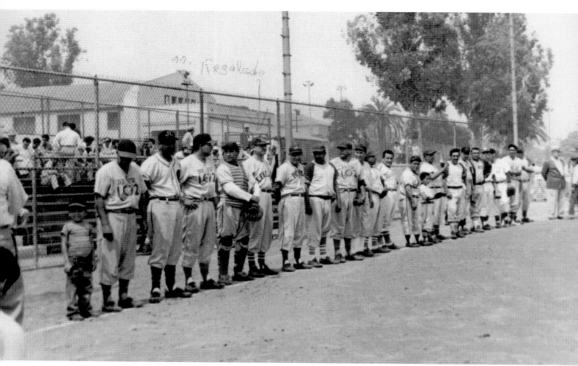

Many former barrio and ex-professional players refused to quit the game as they became older and instead joined the Los Angeles Forty-Sixty Club of veterans. The Forty-Sixty Club and the El Paso, Texas, Club scheduled "goodwill games" twice a year at each other's venue, often on a holiday weekend such as Memorial Day or Labor Day. The games in El Paso often attracted family and friends from Ciudad Juárez, who would cross the international border to attend the games and dances that followed. Moreover, the Forty-Sixty Club played Mexican teams extensively, including clubs from Hermosillo, Sonora; San Luis, Sonora; Chihuahua, Chihuahua; Ciudad Juárez, Chihuahua; Delicias, Chihuahua; and San Luis Río Colorado, Sonora.

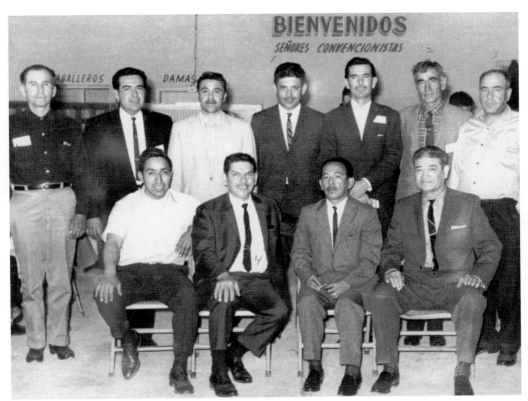

A baseball convention of Mexican and Mexican American clubs was held in Hermosillo, Sonora, around 1960. Manager Manuel Regalado of the Los Angeles Forty-Sixty Club is seated above in the first row at the far right. Pictured below, also seated at the proceedings, are convention delegates from the Thirty-Forty baseball club of Hermosillo, Mexico.

MEXICAN AMERICAN BASEBALL IN LOS ANGELES

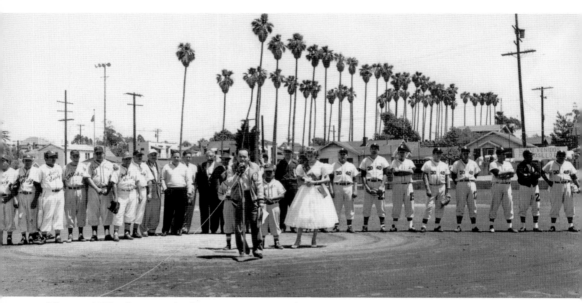

This *c.* 1959 photograph documents a game between the Los Angeles Forty-Sixty Club and the Hermosillo Thirty-Forty Club at Evergreen Park. Saul Toledo is master of ceremonies at the microphone. Forty-Sixty Club queen is Margie Sepúlveda, and veteran manager Manuel Regalado is in black behind the queen.

PROFESSIONAL BASEBALL
AMERICAN DREAMS
FOR MEXICAN AMERICANS

The reason I got started in baseball was because my Dad was a great baseball player in Arizona. He played for the Southern Pacific Company. . . . He was so good he was offered a professional contract. His father, my grandfather, would not let him go, because he was the sole support of the family.

—Al Padilla, oral history interview
Mexican American Baseball Project, California State University, Los Angeles

When I came here from Mexico, most of the Mexican people wanted their kids to go to work. Hard labor. No school. Everybody was working just to get by and the kids didn't get a lot of chances for something better.
My mother never encouraged me because she didn't know what baseball was, but from semipro on, my dad was always there when I played. I was going to school and every Saturday and Sunday I worked to help the family. My brother used to catch me and he's the one who said, 'Go on and play baseball, see if you can make it.' Well, I got out and I tried and I made it. I think without baseball I would have been just another worker.

—Jesse Flores, major-league pitcher (1942–1950)
For the Love of the Game: Baseball Memories from the Men Who Were There

Many Mexican American players performed exceptionally well at various levels and venues of baseball competition. Numerous Mexican American ballplayers were taught and trained at local recreational centers, as well as in high school and collegiate programs. Ballplayers also polished their baseball skills as members of barrio teams. The dream of a professional career became a possibility for talented and skilled Mexican American players. However, baseball scouts often overlooked the ability and potential of these players, especially during the period of early-20th-century segregation. On the other hand, Mexican American players often refused major-league baseball offers because of obligations to help support their families. Nevertheless, some Mexican Americans did reach the world of professional baseball and were not only star players, but also coaches and scouts.

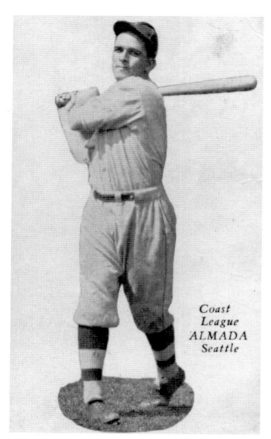

Coast
League
ALMADA
Seattle

Louie Almada was born in Mexico and raised in Los Angeles. While his strong pitching earned Los Angeles High School a place in the city championships of 1925–1926, Almada was invited to the New York Giants spring-training camp in 1927. He failed to win a spot on the major-league roster. Louie switched to the outfield and became a popular player in the Pacific Coast League for the Seattle Indians and San Francisco Mission Reds from 1929 to 1937.

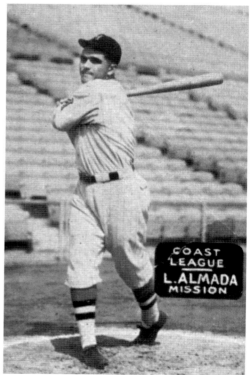

Baldomero "Melo" Almada, the younger
brother of Louie Almada, was also born in
Mexico and raised in Los Angeles. Like his
brother, Mel's pitching brought Los Angeles
High School to the city championships
in 1930–1931. By 1933, Mel was the first
Mexican to play in the major leagues.
Almada was a center fielder who was signed
out of the Pacific Coast League by the
Boston Red Sox. He played in the major
leagues from 1933 to 1939 for the Boston
Red Sox (1933–1937), St. Louis Browns
(1938–1939), and Brooklyn Dodgers (1939).

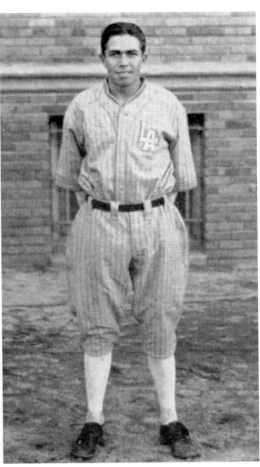

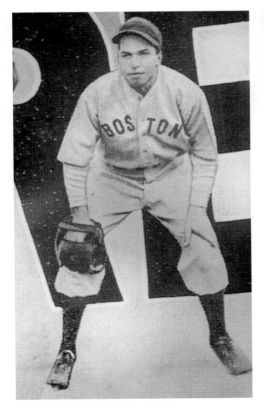

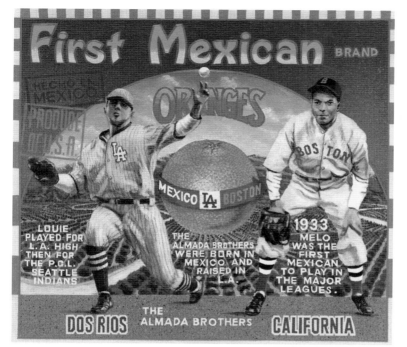

First Mexican Brand by artist Ben Sakoguchi pays homage to the Mexican-born and Los Angeles–raised Louie and Baldomero "Melo" Almada. (Courtesy of Ben Sakoguchi.)

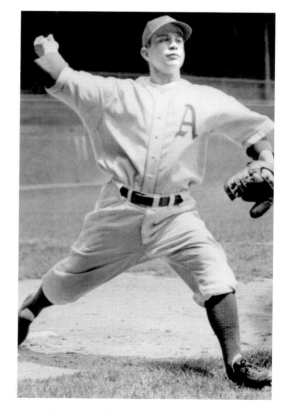

Born in Guadalajara, Mexico, in 1914, Jesse Flores was raised in Southern California. Flores's mother resisted his pursuit of a baseball career. "She used to go to church and pray for me when I was pitching. She thought I was going to get hit in the head with the ball," Flores recalled. He played in the major leagues from 1942 to 1950 with the Chicago Cubs, Philadelphia Athletics, and Cleveland Indians. After his retirement, Flores was a highly successful baseball scout for the Philadelphia Phillies, Minnesota Twins, and Pittsburgh Pirates.

Henry John "Hank" Aguirre was named the "Tall Mexican" by sportswriters because of his 6-foot, 4-inch height. Artist Ben Sakoguchi memorialized Aguirre in his painting *Tall Mexican Brand*. Born and raised in Azusa, California, Aguirre delivered tortillas for the family business before playing sandlot and legion baseball. While playing for East Los Angeles Community College, he was signed by the Cleveland Indians in 1951 and was brought up to the parent club in 1955. Aguirre had a highly successful 16-year major-league career as a starter and relief pitcher. His best year was in 1962, when he was 16-8 and led the American League in earned run average (2.21) for the Detroit Tigers. (Below, courtesy of Ben Sakoguchi.)

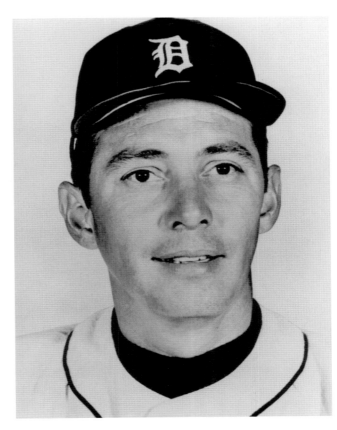

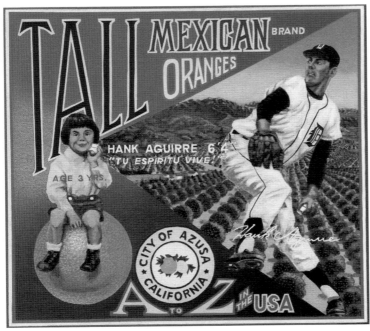

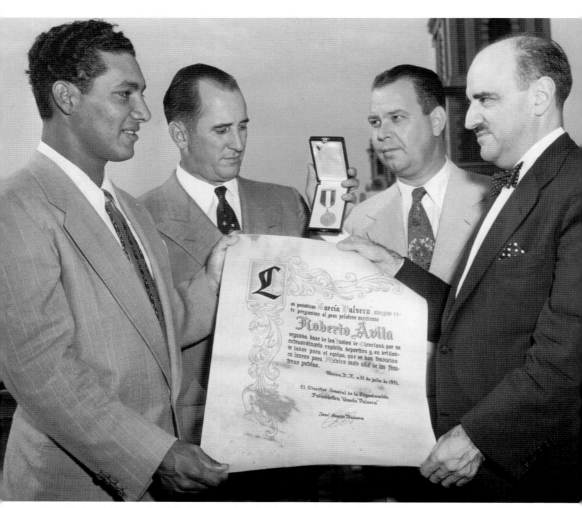

In 1951, Roberto "Bobby" Gonzáles Avila was honored in Washington, D.C., by Mexican ambassador Rafael de la Colina (far right) and was awarded a medal from Mexican sportswriters. De la Colina was an avid baseball fan and former Mexican consul of Los Angeles. While serving as consul in Los Angeles during the 1930s, he often attended games of Mexican American as well as Mexican teams at the local White Sox Park.

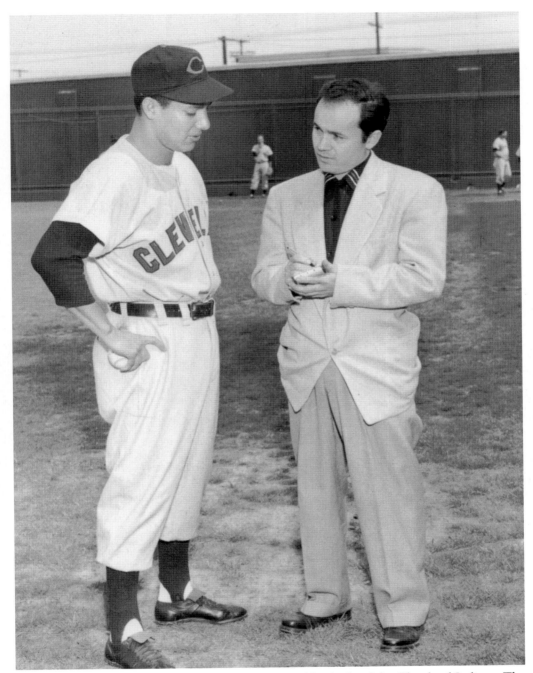

In this photograph, Saul Toledo (right) interviews Bobby Avila of the Cleveland Indians. The Mexican-born star was popular in the Mexican community, especially because he was the first Latino player to win a batting title in major-league baseball (.341 in 1954).

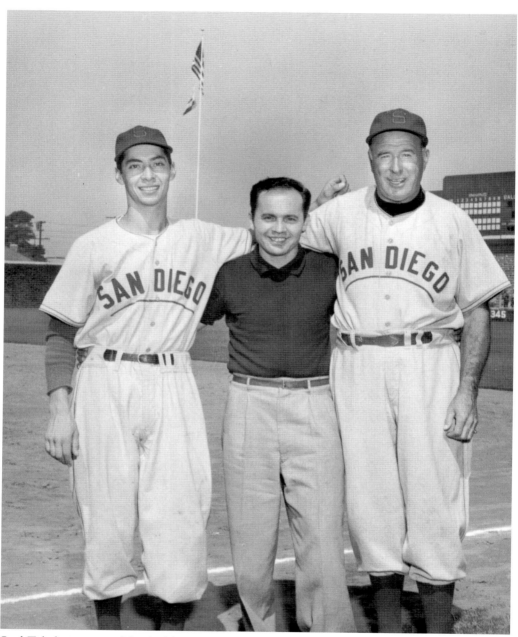

Saul Toledo is pictured flanked by Mexican-born pitcher Memo Luna (left) and manager Lefty O'Doul of the San Diego Padres (right). Luna played for the Padres of the Pacific Coast League, but his career was cut short by an arm injury.

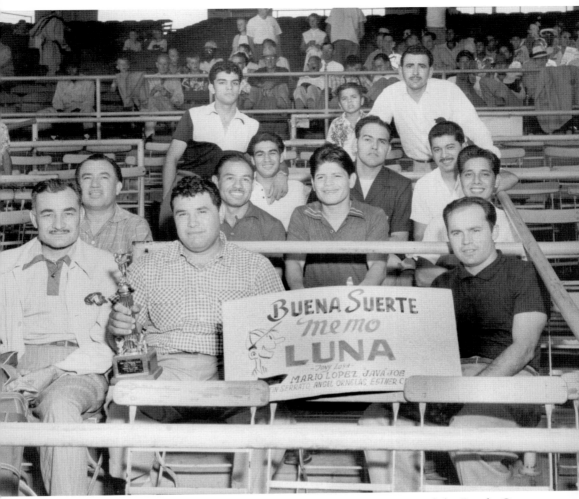

At Wrigley Field in Los Angeles, San Diego Padres pitcher Memo Luna of the Pacific Coast League was honored at a ceremony with Saul Toledo, here holding a sign in support of Memo Luna. Directly behind the sign and Toledo are Enrique Bolanos (left) and Lalo Rios (right). Bolanos was a top-rated lightweight boxer, who contended for the title in the mid-to-late 1940s, and Rios was a major actor who starred in 10 films during the 1950s.

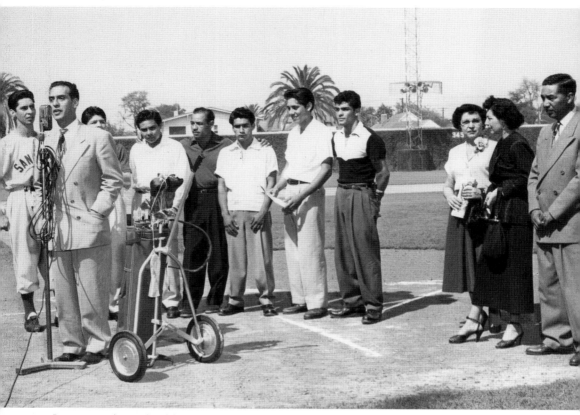

City councilman (and later Congressman) Edward Roybal, along with other dignitaries, speaks into the microphone at an event on behalf of Memo Luna at Wrigley Field. The event underscored that baseball and community, with boxer Enrique Bolanos and actor Lalo Rios, were clearly linked during this period of progressive politics in support of equality and social change for the Mexican community.

PROFESSIONAL BASEBALL

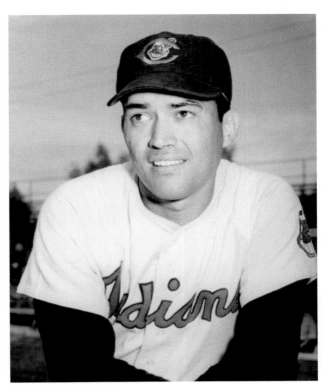

Rudolph Valentino "Rudy" Regalado, son of longtime Los Angeles Mexican community baseball organizer and manager Manuel Regalado, starred at Hoover High School in Glendale and at the University of Southern California in 1949 and 1950. Regalado was signed by the Cleveland Indians organization and played with the parent club from 1954 to 1956, appearing in the 1954 World Series.

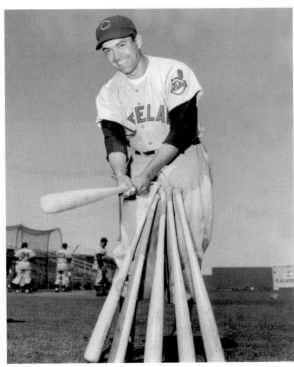

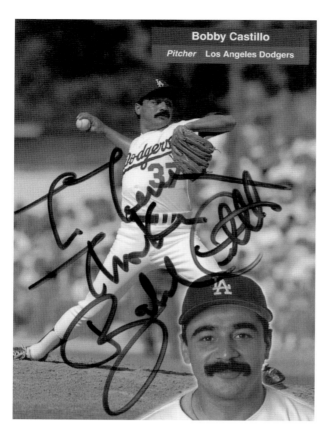

Bobby Castillo
Pitcher Los Angeles Dodgers

Bobby "Babo" Castillo was one of the greatest baseball stars from East Los Angeles. Castillo was a three-time all-city player at Lincoln High School. He pitched in 250 games for the Los Angeles Dodgers and Minnesota Twins in a nine-year career from 1977 to 1985. Castillo also taught the young Fernando Valenzuela how to throw the screwball, which would become the Mexican superstar's signature pitch.

Armando Pérez was a 1955 Roosevelt High graduate who also played barrio ball with the Chorizeros. He would later play for the Baltimore Orioles' minor-league teams. After retiring from playing baseball, Pérez dedicated his life to youth by teaching and coaching in Southern California and has contributed significantly to the development of the Montebello Stars Baseball Association. His efforts have resulted in scholarships for many young Mexican American ballplayers.

Ernie Rodríguez had an extraordinary baseball career, ranging from playing to coaching. Rodríguez played community, high school, college, and minor-league ball. In this photograph of the 1962 Omaha Dodgers, he sits in the first row, second from the left.

Ernie Rodríguez was successful in transitioning from player to coach, managing a number of teams, including the Pocatello Posse for the Independent League in Idaho and the Great Falls (Montana) Giants in the Rookie League. After a successful career coaching professionally, Rodríguez returned to his alma mater, Roosevelt High School, to manage the baseball team and teach. During a time when few baseball scouts would venture to East Los Angeles, Ernie served as a critical link for high school, collegiate, and professional ballplayers.

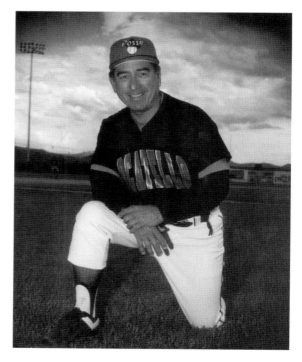

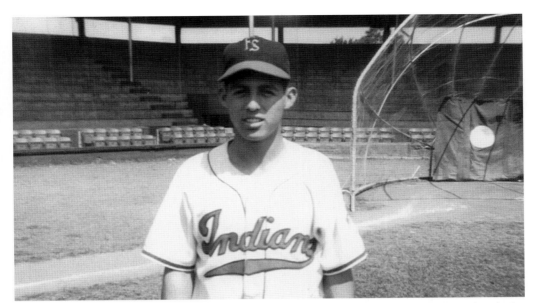

After playing baseball at Roosevelt High School and Eastside Beer, Ernie Blanco signed with the Cleveland Indians and reported to spring training in Daytona Beach, Florida. He was assigned to the Spartanburg, South Carolina, Peaches Class C team and named to the 1952 Minor League All-Star team, beating out some excellent players who later went on to the majors. In 1952, he was drafted into the military and served in Korea, playing service ball for a year. After returning home in 1955, the Cleveland Indians asked him to report to spring training. Blanco was assigned to a farm team in Fargo, North Dakota. Unfortunately, Blanco's career was cut short due to family financial demands. After attempting to play professional ball closer to home, Blanco decided to play barrio ball with the Chorizeros.

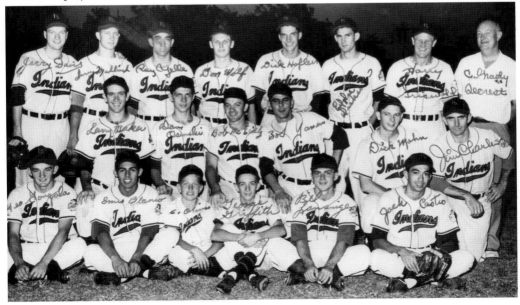

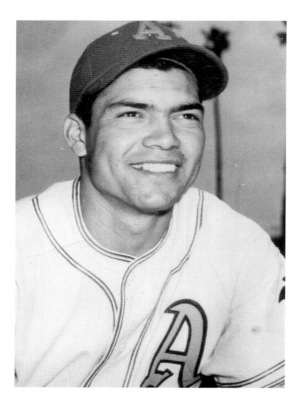

Among the Chorizeros and the famous Peña brothers, John Peña also played for the Anaheim Valencias in the Sunset League during the 1950s.

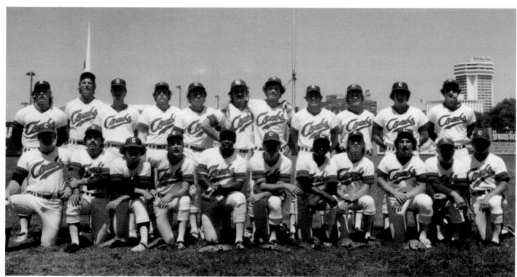

Garfield High School graduate and California State College, Los Angeles pitcher Alfredo Esparza had an outstanding collegiate career, leading his team to Omaha, Nebraska, and the College World Series, a tournament more often featuring established Southern California institutions such as UCLA and USC. Esparza (first row, sixth from left) also played for the Humboldt Crabs in Arcata, California.

DODGER BASEBALL
CHÁVEZ RAVINE TO "FERNANDOMANIA"

Every time I see the book [photographs of Chávez Ravine] I see the house where I was born, my daughter, my wife. I feel like crying. It was very nice up here. To me, it was like a little ranch . . . it is a beautiful stadium. I love the Dodgers. I also was a fan of them and hoping someday to work inside the stadium as a caretaker. Never made it.

—Gilbert Hernández
Chávez Ravine: A Los Angeles Story

What happened with Chávez Ravine motivated us to go to college; it made us stronger and more educated so that this would never happen to us again. It made us reach for higher goals.

—Carmen Nava, oral history interview
Mexican American Baseball Project, California State University, Los Angeles

Valenzuela became an instant object of adulation in L.A.'s Latino community, which was, and is, overwhelmingly of Mexican origin. Latin American big leaguers were no longer a novelty, but most were from the Caribbean. And Valenzuela was a rare double-crossover hit: Not only did he attract Latinos and non-Latinos, his following transcended the broad cultural chasm between Mexican immigrants and U.S.-born Mexican Americans.
The extra fans he drew kicked off an upward trend in Latino attendance at Dodger Stadium that continues. Valenzuela even helped smooth some of the hard feelings that remained from the bulldozing in 1959 of hundreds of homes in the tight knit Mexican American communities of Chavez Ravine to make way for the ballpark. Latinos now represent one-third of the Dodger fan base.

—Patrick J. McDonnell, *Los Angeles Times*, July 9, 2001

The ousting of the largely Mexican community from Chávez Ravine to build Dodger Stadium was regarded as an act of ruthless power by the City of Los Angeles and the Dodgers against a poor and powerless working-class community. However, this tragedy of the 1950s underscored the lack of political power and contributed to fueling the Chicano movement and empowerment in the 1960s. Surprisingly, the arrival of the Dodgers contributed significantly to the Mexican community's pride.

The Dodgers attracted Mexican fans by broadcasting games and printing programs in Spanish, but the key to the Mexican fan base was Fernando Valenzuela's meteoric success, which provided an extraordinary opportunity to celebrate Mexican achievement and success in baseball and American society.

HOUSING AUTHORITY OF THE CITY OF LOS ANGELES

1401 EAST FIRST STREET
TELEPHONE ANGELUS 2-2121

COMMISSIONERS
NICOLA GIULII, CHAIRMAN
LLOYD A. MASHBURN
VICE-CHAIRMAN
J. E. FISHBURN, JR.
MAURICE SAETA
GEORGE A. BEAVERS, JR.

EXECUTIVE DIRECTOR
HOWARD L. HOLTZENDORFF

BOX 2316 TERMINAL ANNEX
LOS ANGELES 54, CALIFORNIA

July 24, 1950

To The Families of The Palo Verde and Chavez Ravine Areas:

This letter is to inform you that a public housing development will
be built on this location for families of low income. The attached
map shows the property that is going to be used. The house you are
living in is included.

Within a short time surveyors will be working in your neighborhood.
Later you will be visited by representatives of the Housing Authority,
who will ask you to allow them to inspect your house in order to
estimate its value. Title investigators will also visit you. You should
be sure that any person who comes to your house has proper identification.

It will be several months at least before your property is purchased.
After the property is bought, the Housing Authority will give you all
possible assistance in finding another home. If you are eligible for
public housing, you will have top priority to move into any of our public
housing developments. Later you will have the first chance to move back
into the new Elysian Park Heights development.

Three offices are being opened in this area to give you information and
answers to your questions. They are located as follows:

> Santo Nino Parochial Hall at 1034 Effie St.,(rear of Church)
> San Conrado Mission at 1809 Bouett, (near Amador St.)
> Tony Visco's old grocery store at 1035 Lilac Terrace

You are welcome to come in at any time. We will be open day and night
this week, July 24 through July 28, and during the day Saturday, July 29.
Next week we will be open during the day and in the evenings by appoint-
ment. Telephone ANgelus 2-1963 for any information.

We want to assure you that it is our intention to help you and work with
you in every way possible.

Yours very truly,

Sidney Green

Sidney Green
Management Supervisor

The Los Angeles City Housing Authority letter in English was issued on July 24, 1950, to the
families of Palo Verde and Chávez Ravine regarding the surveying of properties for the Elysian
Park Heights development. Chávez Ravine was comprised of the mostly Mexican communities of
La Loma, Palo Verde, and Bishop. (Courtesy of the John C. Holland Papers, Special Collections,
California State University, Los Angeles.)

HOUSING AUTHORITY OF THE CITY OF LOS ANGELES

COMMISSIONERS
NICOLA GIULII, CHAIRMAN
LLOYD A. MASHBURN
VICE-CHAIRMAN
J. E. FISHBURN, JR.
MAURICE SAETA
GEORGE A. BEAVERS, Jr.

EXECUTIVE DIRECTOR
HOWARD L. HOLTZENDORFF

1401 EAST FIRST STREET
TELEPHONE ANGELUS 2-2121

BOX 2316 TERMINAL ANNEX
LOS ANGELES 54, CALIFORNIA

Julio 24 de 1950

A los Vecinos de los Distritos de Palo Verde y Chavez Ravine:

La presente es con el fin de informarle a Ud. que un vecindario de habitaciones públicas será edificado en este distrito para familias de recursos limitados. El mapa adjunto indica la propiedad que será utilizada.

En breve tiempo los agrimensores y los investigadores de titulos de propiedades comenzaran a trabajar en su vecindad. Más tarde un representante de la Autoridad de Viviendas le hará una visita para pedirle que le permita inspeccionar su hogar con el fin de evaluarlo. Este seguro que la persona que se presente en su residencia tiene las debidas identificaciones.

Empero, pasaran algunos meses antes de que la propiedad sea comprada. Una vez hecha la compra de su casa y terreno, la Autoridad de Viviendas le ayudara a Ud. de todas las maneras posibles para encontrarle otro hogar. Y si es que Ud. cualifica para obtener una vivienda pública, recibirá prioriedad para mudarse a uno de los proyectos he habitaciones. Mas tarde se le ofrecera a Ud. la primera oportunidad para que pueda volver a residir en la nueva seccion de viviendas en Elysian Park Heights.

Hemos establecido tres oficinas especiales con el fin de contestarle sus preguntas, las cuales estaran situadas en los siguientes lugares:

Salon Parroquial de Santo Niño - 1034 Effie Street - CA 1-9228

Mision de San Conrado - 1809 Bouett (cerca de Amador Street) - CA 2-1352

En la antigua tienda de Tony Visco - 1035 Lilac Terrace

Venga cuando Ud. guste. Las oficinas estaran abiertas por la noche (toda esta semana, julio 24 a 28), asi como cualquiera otra noche que Ud. lo desee, haciendo su cita por anticipado, llamando por telefono al numero, ANgelus 2-1963.

Queremos asegurarle que es nuestro sincero deseo el poderle ayudar y trabajar con Ud. de todas las maneras posibles.

Muy Atentamente,

Sidney Green

Sidney Green
Management Supervisor

The Los Angeles Housing Authority letter was also circulated in Spanish. The controversy over Chávez Ravine began long before the arrival of the Dodgers in Los Angeles. Drawing funds from the Federal Housing Act of 1949, the City of Los Angeles employed eminent domain to develop the Elysian Park Heights public housing project. (Courtesy of the John C. Holland Papers, Special Collections, California State University, Los Angeles.)

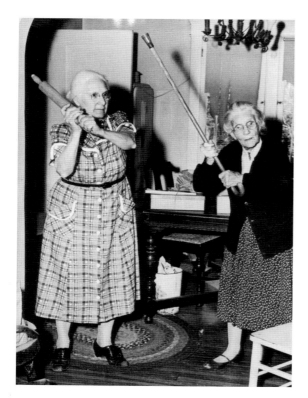

Awaiting eviction from Chávez Ravine are Alice Martin (left), 73, and Ruth Rayford, 85, but according to the reporter, "Not without a fight!" Los Angeles negotiated with the federal government and was able to officially abandon the housing project if the land was used for a "public purpose." Los Angeles exchanged the Chávez Ravine site for the smaller location of Wrigley Field, which was owned by Walter O'Malley and the Dodgers. (Courtesy of the *Herald-Examiner* Collection, Los Angeles Public Library.)

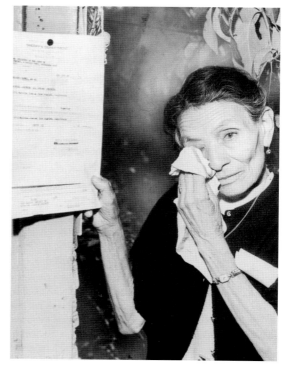

While reading an eviction notice placed on her home by deputy sheriffs, Abrana Arechiga weeps. Two families were forced to leave the property by 9:00 a.m. the following Monday to make way for the new Dodger ballpark. (Courtesy of the *Herald-Examiner* Collection, Los Angeles Public Library.)

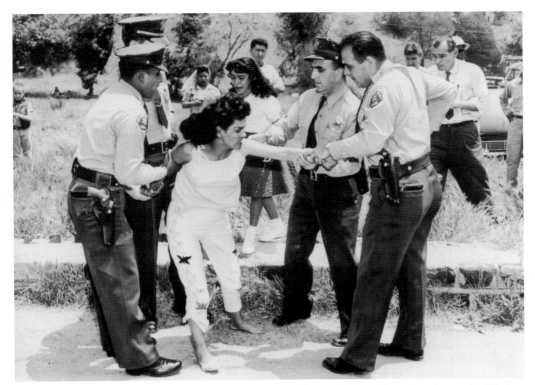

Los Angeles County sheriffs are pictured removing Aurora Vargas from her home in Chávez Ravine. Shortly after Vargas's removal, bulldozers knocked over the remaining homes. Many residents of Chávez Ravine resisted eviction, including Aurora Vargas, who vowed, "They'll have to carry me [out]." Four months later, ground-breaking for Dodger Stadium began. (Courtesy of the *Herald-Examiner* Collection, Los Angeles Public Library.)

Eviction from Chávez Ravine was directed against Abrana Arechiga (left) and her daughter Vicki Augustain in front of what remains of their homes, which were destroyed by bulldozers in order to make way Dodger Stadium. (Courtesy of the *Herald-Examiner* Collection, Los Angeles Public Library.)

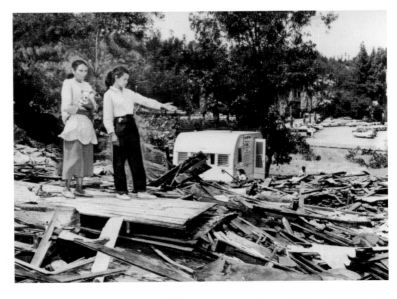

In the 1930s, Ruth Nava, a longtime resident of Chávez Ravine, lived with her husband, Alejandro Nava, and family at 1845 Malvina Avenue.

This is a photograph of the First Communion Class of 1950 for Santo Niño, Holy Child Catholic Church. Santo Niño was a key religious, social, and cultural center for the Chávez Ravine community before the church was leveled for the building of Dodger Stadium.

DODGER BASEBALL

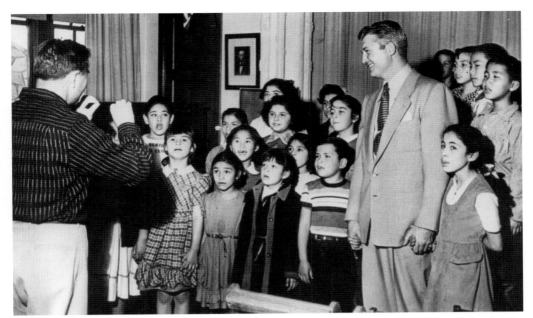

In 1955, popular Superman television star George Reeves visited Solano Elementary School. The class included six children who were transferred to Solano after closure of the local Chávez Ravine school, Palo Verde Elementary. George Reeves spoke in Spanish and sang Mexican ballads to the students. The Nava children missed the school bus the day of Superman's visit. The children were thrilled when Superman graciously offered to drive the children home to Chávez Ravine.

Pictured celebrating Easter Sunday in 1950 in Chávez Ravine are the Nava children. From left to right they are Carmen, Alex, an unidentified cousin, Manuel, and Lupe.

After leaving Chávez Ravine, the Nava family moved to the El Sereno section of Los Angeles. This 1965 photograph was taken during Carmen Nava's wedding in front of the family's new home.

Pictured from left to right, Carmen, Manuel, and Lupe Nava recalled their Chávez Ravine experiences in an oral history interview with California State University, Los Angeles students. The Nava family was one of the last to leave Chávez Ravine. As was the case with other families who were among the last to leave, they received more compensation from the Dodgers than other families who accepted reimbursement from the City of Los Angeles years earlier.

On September 17, 1959, Dodger owner Walter O'Malley displayed a souvenir shovel at the ground-breaking ceremonies at Chávez Ravine for the construction of Dodger Stadium. (Courtesy of the *Herald-Examiner* Collection, Los Angeles Public Library.)

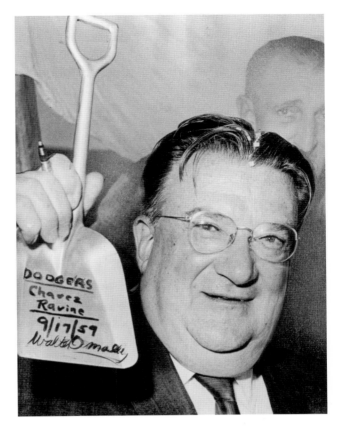

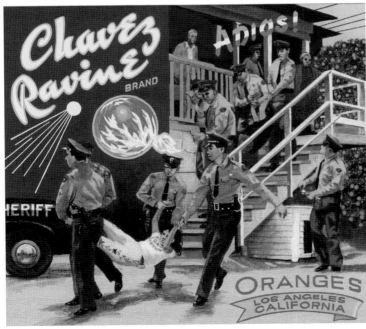

In dramatic contrast to the above image, artist Ben Sakoguchi's *Chavez Ravine Brand* offers an "adiós!" to the residents of Chávez Ravine. (Courtesy of Ben Sakoguchi.)

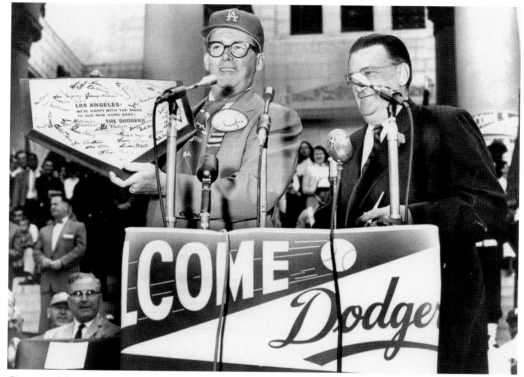

Civic and business communities enthusiastically welcomed Walter O'Malley and the Dodgers as an opportunity for Los Angeles to rank alongside the major cities in the United States. An especially ardent supporter was Los Angeles mayor Norris Poulson, who appears above in a Dodger cap with O'Malley. (Courtesy of the *Herald-Examiner* Collection, Los Angeles Public Library.)

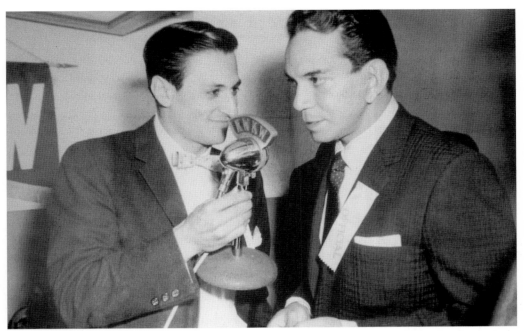

When the Dodgers moved to Los Angeles in 1958, Jaime Jarrín became the Spanish-speaking voice of the Dodgers on radio station KWKW. For some six years, Jarrín did not travel with the team and instead re-created the games on radio while listening to the English-language broadcast in a studio. Jarrín's broadcasting made him a celebrity in Los Angeles, and he enjoyed a popularity among Mexicans equivalent to the famous comic Cantinflas (above) and actor Ricardo Montalban (below). His radio broadcasting of Dodger games successfully linked the Mexican community of Los Angeles to the Dodger team.

During his time as the translator for Fernando Valenzuela, Jaime Jarrín further connected the Mexican and Mexican American communities to the spectacular success of Valenzuela and the Dodgers.

In *Solamente Inglés Brand* (Only English), artist Ben Sakoguchi highlights the Valenzuela–Jarrín relationship and the issue of language in baseball and Los Angeles. (Courtesy of Ben Sakoguchi.)

DODGER BASEBALL

Dodgers scout Mike Brito, seen at right, famously remarked, "I'd go to sleep in the jungle . . . with snakes crawling all around me . . . to find another Fernando." Brito also organized a Sunday League to encourage the growth of Mexican American talent among the Mexican and Latino Southern California communities. In the photograph below, Fernando Valenzuela waits in the Dodger dugout. (Courtesy of the *Herald-Examiner* Collection, Los Angeles Public Library.)

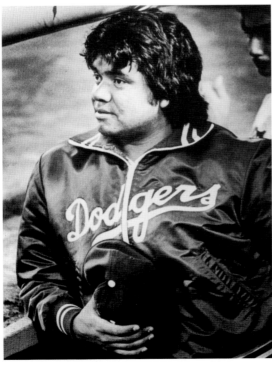

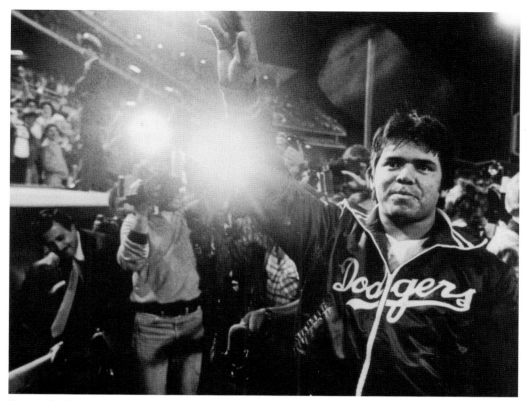

Fernando Valenzuela salutes the fans after a pitching performance. Fernandomania swept through Los Angeles in 1981 as Valenzuela began his career with an 8-0 record, eventually leading the Dodgers to the World Series. That season, Valenzuela won both the Cy Young and Rookie of the Year Awards. With his unorthodox wind-up and unusual physique for a baseball player, Fernando Valenzuela drew large crowds at Dodger Stadium as well as other major-league stadiums. (Courtesy of the *Herald-Examiner* Collection, Los Angeles Public Library.)

During the 1981 off-season, Fernando Valenzuela served as the grand marshal of the annual East Los Angeles parade. Valenzuela's Mexican background not only charmed the Mexican population of East Los Angeles but also that of greater Southern California with its own growing Mexican population. Mexican citizens also traveled from the Mexican nation to see their native son pitch for the Dodgers. (Courtesy of the *Herald-Examiner* Collection, Los Angeles Public Library.)

Fabulous Fernando pennants on sale outside of Dodger Stadium were one of the many Fernando Valenzuela souvenirs during the Fernandomania era of the 1980s. (Courtesy of the *Herald-Examiner* Collection, Los Angeles Public Library.)

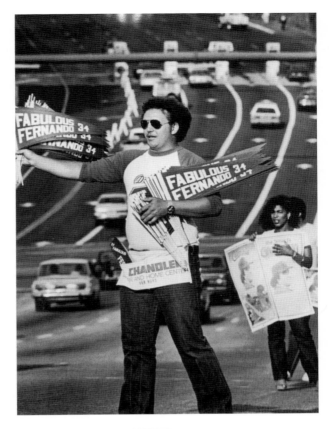

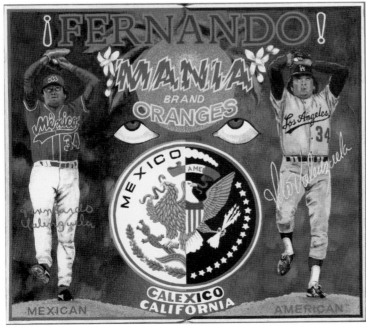

Artist Ben Sakoguchi created this Mexican American interpretation called *¡Fernando! Mania Brand*. (Courtesy of Ben Sakoguchi.)

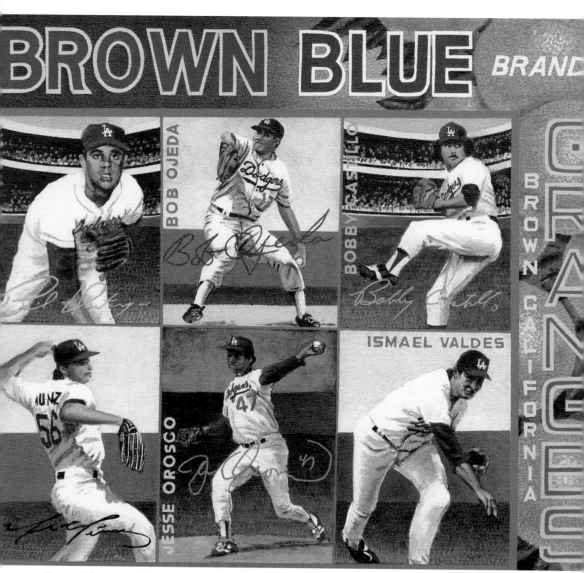

Brown Blue Brand by artist Ben Sakoguchi underscores the bonds of Dodger Blue and Mexican Brown established by Mexican and Latino players. (Courtesy of Ben Sakoguchi.)

BASEBALL LEGACY
LATINO BASEBALL HISTORY PROJECT

Much of the history that is being shown has been shoved from modern consciousness. A world of baseball played on barrio sandlots thrived throughout Southern California. From the 1940s until the early 1960s, these amateur and semipro players displayed an incredible talent for the game and demonstrated teamwork and leadership. The most touching moments from today's opening ceremonies was the attendance of the older players with two and even three generations of their families. Grand and great-grandparents with their loved ones. These old time ball players truly have lived the American dream. These Chicanos have blazed a path of success through a world of landmines, obstacles, and prejudices.

—Ken Aven
"Mexican-American Baseball in Southern California"

Whereas it is recognized by the City of Los Angeles, that because of an intolerance against non-white players during the early mid-20th century, Mexican American baseball players struggled to pursue their passion beyond the ranks of semiprofessional baseball. However, in the spirit of teamwork, compassion, and the love of baseball, racial tensions never seemed to dampen the spirits of Mexican American players of East Los Angeles, for they were able to put negative realities aside during every Sunday game; and now, therefore, be it resolved with the concurrence of the Mayor, that by the adoption of this Resolution, the City of Los Angeles hereby honors the once-flourishing culture of amateur and semiprofessional baseball, referred to as the "Golden Age of Community Baseball in East Los Angeles," as an important means for Mexican Americans to celebrate ethnic identity, instill community pride, and find a place for themselves in American Society.

—City Councilmember José Huizar's Resolution
Los Angeles City Council, September 21, 2007

This is the first book dedicated to the impact of baseball on the Southern California Mexican community. Far from comprehensive and definitive, it is rather an exploration, remembrance, and tribute. It is also an invitation for further investigation. Not only has new material been uncovered, but issues and themes have emerged for analysis and interpretation. Fortunately, the Latino Baseball History Project is willing and ready to assist in the recovery, documentation, exhibition, and dissemination of Mexican American baseball. The following highlights activities of the Latino Baseball History Project in ensuring the baseball legacy of Mexican Americans.

Saul Toledo was "Mr. Baseball" of East Los Angeles, probably doing more than anyone to promote community baseball. He was a player, coach, public-address announcer, sportswriter, radio broadcaster, and much more. Toledo also coined the name "Los Chorizeros" for the Carmelita Provision Company in 1948. Furthermore, Toledo was among the key individuals supporting the establishment of the Latino Baseball History Project. This photograph was taken less than a month before he died at the age of 90 in September 2010.

Another enthusiastic supporter of the Latino Baseball History Project was Bob Lagunas, who came from an outstanding baseball family. His father, Robert "Lakes" Lagunas, was a star in the Texas and Mexican Leagues. Along with his brother Art, they became one of the best shortstop–second base combinations in greater Los Angeles. During the early 1950s, Bob and Art played together at L.A. State College. This photograph of Bob Lagunas is on the same baseball field he helped inaugurate in 1960, fifty years earlier.

The "Mexican American Baseball in Los Angeles: From the Barrios to the Big Leagues" exhibition opened at the John F. Kennedy Library at California State University, Los Angeles, on March 26, 2006, and attracted former ballplayers, their families, and fans. It was common to see grandparents, parents, and children viewing the photographs and artifacts.

Twenty-five ballplayers from the famed barrio teams, including the Carmelita Chorizeros, served as grand marshals of the Second Annual Boyle Heights Multicultural Parade on November 19, 2006. Clearly the East Los Angeles community was celebrating the history and legacy of these baseball icons.

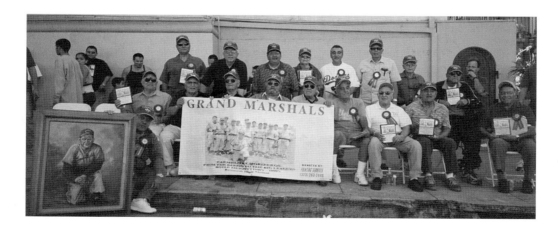

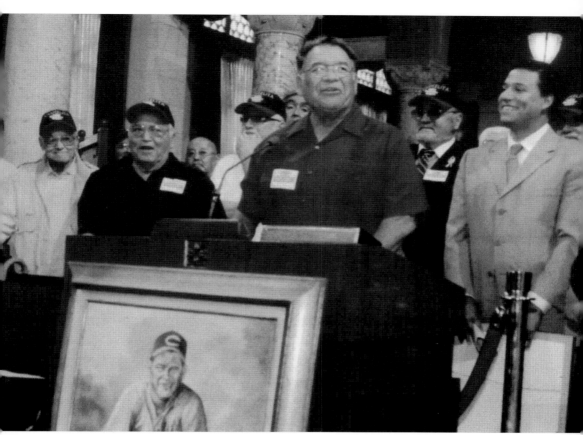

On September 21, 2007, Councilmember José Huizar presented his resolution honoring the "Golden Age of Community Baseball in East Los Angeles" before the Los Angeles City Council. Al Padilla spoke on behalf of his fellow ballplayers.

Chorizero ballplayer Isidro "Chilo" Herrera and his family were among the families attending the inaugural reception of the Latino Baseball History Project at California State University, San Bernardino, on May 12, 2009. The image below of the Inland Empire ballplayers was taken on July 7, 2010, at the Second Old Timers Reunion at Cal State San Bernardino.

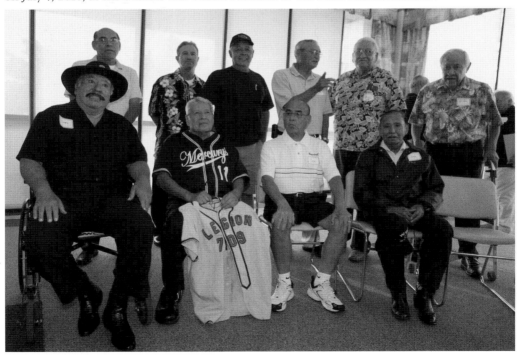

The first artifact donated to the Latino Baseball History Project was this glove presented by Al Padilla that he used during the 1940s.

BIBLIOGRAPHY

Alamillo, José. "Peloteros in Paradise: Mexican American Baseball and Oppositional Politics in Southern California, 1930–1950." *Western Historical Quarterly*, XXXIV: 2, 191–212.

———. "Mexican American Baseball: Masculinity, Racial Struggle and Labor Politics in Southern California, 1930–1960." *Sports Matters: Race, Recreation, and Culture.* New York: New York University Press, 2002.

Avila, Eric. "Suburbanizing the City Center: The Dodgers Move West." *Popular Culture in the Age of White Flight.* Berkeley: University of California Press, 2004.

Chavez Ravine: A Los Angeles Story. PBS Independent Lens Film, 2003.

John C. Holland Papers, Special Collections, California State University, Los Angeles. Los Angeles.

La Historia Society Photograph Collection, La Historia Museo. El Monte, CA.

Herald-Examiner Collection, Los Angeles Public Library. Los Angeles.

Latino Baseball History Project, Special Collections, John M. Pfau Library, California State University San Bernardino. San Bernardino, CA.

Oral History Interviews: Mexican American Baseball in Los Angeles: From the Barrios to the Big Leagues, Special Collections, John F. Kennedy Library, California State University, Los Angeles. Los Angeles.

Normark, Don. *Chavez Ravine 1949: A Los Angeles Story.* Vancouver: Raincoast Books, 1999.

Regalado, Samuel O. "Baseball in the Barrios: The Scene in East Los Angeles Since World War II." *Baseball History* (Summer 1986), 47–59.

———. "Dodgers Béisbol is on the Air: The Development and Impact of the Dodgers' Spanish-Language Broadcasts, 1958–1994." *California History,* (Fall 1995), LXXIV: 3, 280–289.

———. *Viva Baseball: Latin Major Leaguers and Their Special Hunger.* Urbana and Chicago: University of Illinois Press, 1998.

Santillan, Richard A. "Mexican Baseball Teams in the Midwest, 1916–1965: The Politics of Cultural Survival and Civil Rights." *Perspectives in Mexican American Studies,* VII (Tucson: University of Arizona Press), 132–151.

——— and Francisco E. Balderrama. "Los Chorizeros: The New York Yankees of East Los Angeles and the Reclaiming of Mexican American Baseball History." *The National Pastime—The Endless Season: Baseball in Southern California.* Cleveland, OH: Society for American Baseball Research, 2011.

Wilber Cynthia, ed. *For the Love of the Game: Baseball Memories from the Men Who Were There.* New York: William Morrow and Company, 1992.